PICASSO
AND CHICAGO

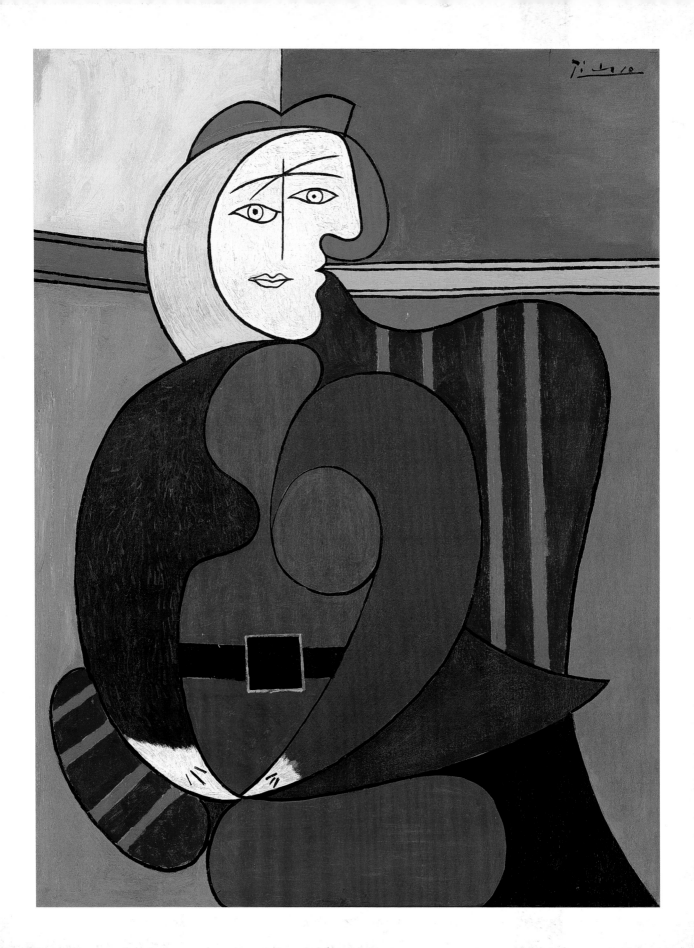

PICASSO
AND CHICAGO

100 YEARS, 100 WORKS

STEPHANIE D'ALESSANDRO

WITH AN ESSAY BY ADAM GOPNIK

THE ART INSTITUTE OF CHICAGO

DISTRIBUTED BY

YALE UNIVERSITY PRESS, NEW HAVEN AND LONDON

Picasso and Chicago: 100 Years, 100 Works was published in conjunction with the exhibition *Picasso and Chicago*, organized by and presented at the Art Institute of Chicago from February 20 to May 12, 2013.

Lead Corporate Sponsor of *Picasso and Chicago* is BMO Harris Bank.

Major funding has been provided by the Auxiliary Board of the Art Institute of Chicago.

 THE AUXILIARY BOARD THE ART INSTITUTE OF CHICAGO

Funding for the exhibition catalogue has been provided by Janice and Philip Beck, Margot and Mark Bowen, Nancy and Steve Crown, Janet and Craig Duchossois, Richard and Gail Elden, Richard and Mary L. Gray, Celia and David Hilliard, Ursula and R. Stanley Johnson, Susan and Lew Manilow, Sylvia Neil and Daniel Fischel, and Segal Family Foundation.

Annual support for exhibitions is provided by the Exhibitions Trust: Goldman Sachs, Kenneth and Anne Griffin, Thomas and Margot Pritzker, the Earl and Brenda Shapiro Foundation, the Trott Family Foundation, and the Woman's Board of the Art Institute of Chicago.

Published by
The Art Institute of Chicago
111 South Michigan Avenue
Chicago, Illinois 60603–6404
www.artic.edu

Distributed by
Yale University Press
302 Temple Street
P.O. Box 209040
New Haven, Connecticut 06520–9040
www.yalebooks.com/art

First edition, second printing
Printed in Canada
Library of Congress Control Number: 2012955085
ISBN 978-0-300-18452-5

Produced by the Publications Department of the Art Institute of Chicago, Robert V. Sharp, Executive Director

Edited by Robert V. Sharp and Wilson McBee
Production by Sarah E. Guernsey and Joseph T. Mohan
Photography research by Lauren Makholm
Designed and typeset in Ideal Sans by Jeff Wonderland, Director, Department of Graphic Design
Separations by Professional Graphics, Inc., Rockford, Illinois
Printing and binding by Friesens Corporation, Altona, Manitoba, Canada

Front jacket: Pablo Picasso, in Mougins, France, 1967, with one of his studies for the *Richard J. Daley Center Sculpture* (see pl. 92). Photograph: Archives, Skidmore, Owings & Merrill.

Back jacket: Pablo Picasso (Spanish, 1881–1973), *Richard J. Daley Center Sculpture* (1963–67), Chicago. Photograph, 2012 © Jamie Stukenberg, Professional Graphics, Inc.

Frontispiece: *The Red Armchair*, December 16, 1931 (pl. 56; cat. 114).

PHOTOGRAPHY CREDITS

Unless otherwise stated, all photographs of artworks appear by permission of the lenders mentioned in their captions. Images of works of art in the collection of the Art Institute of Chicago were produced by the Department of Imaging, Christopher Gallagher, Director. The following credits apply to images for which separate acknowledgment is due.
Figs. 1, 3, 7: Archives, the Art Institute of Chicago. Fig. 2: Ryerson and Burnham Libraries, the Art Institute of Chicago. Fig. 4: Mary Reynolds Collection, Ryerson and Burnham Libraries, the Art Institute of Chicago. Fig. 5: Photograph from the Gertrude Stein and Alice B. Toklas Papers, Yale Collection of American Literature, Beinecke Rare Book and Manuscript Library. Fig. 6: The Bridgeman Art Library. Fig. 9: Photograph by Franck Raux © the Brassaï Estate–RMN-Grand Palais/Art Resource, NY. Fig. 11: © Williams & Meyer, Archives, Skidmore, Owings & Merrill. Fig. 12: Photograph by Roberto Otero © 2012 Artists Rights Society (ARS), New York/VEGAP, Madrid. Fig. 13: Archives, Skidmore, Owings & Merrill. Pls. 1, 15, 29–30, 34, 39, 46, 52, 55, 58, 61–63, 66–69, 76–77, 85–86, 89–91, 94–96: Photographs, 2012 © Jamie Stukenberg, Professional Graphics, Inc. Pl. 60: Photograph, 2012 © James Balodimas. Pls. 74, 84: Photographs courtesy of Sotheby's, Inc. © 2012. Pls. 75, 81–83: Photographs © Christie's Images / the Bridgeman Art Library.

CONTENTS

EXHIBITION AND CATALOGUE SPONSORS

Major funding has been provided by

THE AUXILIARY BOARD OF THE ART INSTITUTE OF CHICAGO

Funding for the exhibition catalogue has been provided by

JANICE AND PHILIP BECK
MARGOT AND MARK BOWEN
NANCY AND STEVE CROWN
JANET AND CRAIG DUCHOSSOIS
RICHARD AND GAIL ELDEN
RICHARD AND MARY L. GRAY
CELIA AND DAVID HILLIARD
URSULA AND R. STANLEY JOHNSON
SUSAN AND LEW MANILOW
SYLVIA NEIL AND DANIEL FISCHEL
SEGAL FAMILY FOUNDATION

Annual support for exhibitions is provided by the Exhibitions Trust

GOLDMAN SACHS
KENNETH AND ANNE GRIFFIN
THOMAS AND MARGOT PRITZKER
THE EARL AND BRENDA SHAPIRO FOUNDATION
THE TROTT FAMILY FOUNDATION
THE WOMAN'S BOARD OF THE ART INSTITUTE OF CHICAGO

LEAD CORPORATE SPONSOR

BMO Harris Bank

Celebrating more than 150 years of rich history in the city of Chicago, BMO Harris Bank is proud to be the lead corporate sponsor of *Picasso and Chicago*—the first major Picasso exhibition organized by the Art Institute of Chicago in almost thirty years. The exhibition coincides with the centennial of the Armory Show at the Art Institute, the show in which Picasso's works were displayed in an American museum for the first time.

The exhibition features Picasso's extensive material experimentations and subjects that are characteristic of the artist, including masterpieces from his Blue and Rose Periods, his Cubist years, and his post–World War II production, and it also highlights his notable contribution to public art in the city of Chicago.

BMO Harris Bank recognizes the special place of great art in Chicago's history. The city's reputation for excellence in the arts continues with *Picasso and Chicago*. At BMO Harris Bank, we support the Art Institute of Chicago and the many other institutions that educate, enlighten, and enrich our communities and ourselves because we believe that when we know more about the world around us, we're better prepared to make a positive impact.

We hope you enjoy this book and that it provides a beautiful reminder of this illuminating exhibition.

FOREWORD

The Armory Show of 1913 was a landmark event in the history of modern art, showcasing the works of the most radical European artists of the day alongside their progressive American contemporaries. Presented in three venues—New York, Chicago, and Boston—this exhibition introduced modern art to American audiences and forever changed the aesthetic landscape for artists, collectors, critics, and cultural institutions in this country. As the only art museum to host the Armory Show—which was first mounted at the 69th Regiment Armory in New York and was later sponsored by the Copley Society of Boston—the Art Institute enjoys the distinction of being the first museum in the United States to present the works of such artists as Constantin Brâncuși, Marcel Duchamp, Henri Matisse, and Pablo Picasso. Since that historic event, Chicago has solidified itself as a place for the new and the modern: indeed, countless notable exhibitions and acquisitions of modern art in both the private and public spheres have followed over the years. Numerous collectors and institutions in this city have embraced Picasso's work, as well as that of other modernists, and the Art Institute's distinguished collection of modern art has been the beneficiary of this legacy. On the centennial anniversary of the Armory Show, *Picasso and Chicago* celebrates the special relationship that our city has had with one of the greatest artists of the twentieth century.

For her dedication, intellect, and inspired leadership of this museum-wide celebration, I am most grateful to Stephanie D'Alessandro, Gary C. and Frances Comer Curator of Modern Art. I am also thankful to many other Art Institute colleagues for their exceptional contributions to the realization of this catalogue and the exhibition it accompanies. These projects enhance our understanding of Picasso's art and career, and deepen our appreciation of Chicago's essential role in the support of modern art in the United States. In addition, I am indebted to Adam Gopnik, longtime staff writer for the *New Yorker* and author of many essays on modern art, for his thoughtful meditation on Picasso.

No celebration of Chicago's relationship with Picasso would be complete without including the significant supporters of the artist's work throughout the city, and we are extremely grateful to the many private collectors, as well as to the Arts Club of Chicago and the Philadelphia Museum of Art, for so generously sharing their treasures with us. Finally, we also acknowledge those who have provided crucial support for this catalogue and the generous donors who have made possible the organization of this exhibition: BMO Harris Bank and the Auxiliary Board of the Art Institute of Chicago.

DOUGLAS DRUICK

President and Eloise W. Martin Director
The Art Institute of Chicago

PREFACE AND ACKNOWLEDGMENTS

It is clear in even the briefest of histories that Chicago played a critical, early role in the reception and development of modern art in the United States. While the career of Pablo Picasso is just one of many examples, it is nonetheless an extraordinary story: some of the most significant events in the reception of his art—including the first presentation of Picasso's works at an American art museum, the first solo show devoted to the artist outside a commercial gallery, and the first permanent display of his work in an American museum—all happened in Chicago and all within just the first two decades of the last century. This catalogue and the exhibition it accompanies celebrate the special hundred-year relationship of Pablo Picasso, the preeminent artist of the twentieth century, and our city. The chronology that follows documents the events of Picasso's career and the growth of Chicago's cultural institutions, and the storied moments of overlap that have contributed not only to the vibrant interest in Picasso today but also to the presence of nearly four hundred works by the artist in the collection of the Art Institute of Chicago.

The museum began its collection of the work of this artist in the early 1920s with two figural drawings (*Sketches of a Young Woman and a Man* and *Study of a Seated Man*, from 1904 and 1905, respectively) and in 1926 welcomed the iconic *Old Guitarist* (late 1903–early 1904) as a generous gift of the Helen Birch Bartlett Memorial Collection. Over the years the collection has expanded to include such important paintings as the classically

inspired *Mother and Child* (1921) and the Surrealist *Red Armchair* (1931), as well as such memorable sculptures as the Cubist *Head of a Woman (Fernande)* (1909), the playful *Figure* (1935), and the maquette for Picasso's largest three-dimensional work, the *Richard J. Daley Center Sculpture* (1964–67). Over time, the Art Institute has also developed an exceptional collection of works on paper that demonstrates the endless inventiveness of Picasso's thinking and the skill of his draftsmanship, as seen in such extraordinary examples as the turbulent *Minotaur* (1933) and the monumental *Woman Washing Her Feet* (1944). Likewise, the print collection holds special works including *The Frugal Meal* (1904), one of only three examples of this familiar Blue Period etching printed in blue-green ink.

Picasso and Chicago affords a rare opportunity to experience the great quality and range of Picasso's work in all media at the museum, but this is only part of the story: also critical is the remarkably early and strong support of Picasso's art by Chicagoans, including Arthur Jerome Eddy (1859–1920), Rue Winterbotham Carpenter (1876–1931), and Frederic Clay Bartlett (1873–1953) and Helen Birch Bartlett (1883–1925), as well as celebrated collectors from later in the century including Elizabeth "Bobsy" Goodspeed (later Mrs. Gilbert W. Chapman, 1893–1980), Samuel A. Marx (1885–1964) and Florene May Schoenborn (1903–1995), Leigh (1905–1987) and Mary Lasker Block (1904–1981), and Joseph (1904–1996) and Jory (d. 1993) Shapiro. While Picasso was not the sole

focus of these individuals' collecting, his work remained foundational, and this energetic and bold legacy continues.

Today we are tremendously grateful to all those individuals who have so generously loaned their treasures to this celebratory centennial exhibition: Nancy and Steve Crown, Richard and Gail Elden, Francey Gecht, Richard and Mary L. Gray, Ursula and R. Stanley Johnson, Susan and Lew Manilow, and Sylvia Neil and Daniel Fischel, as well as several anonymous private collectors. In addition, we are grateful to the Arts Club of Chicago for making their important drawing available for loan to the exhibition; for their essential cooperation and support, we thank Sophia Siskel, President of the Board of Directors, and Janine Mileaf, Director of the Arts Club. Sincerest thanks to all those who shared their works with us for this exhibition, augmenting and deepening what we are able to present from the Art Institute's collection in order to make the exhibition truly a citywide celebration.

This exhibition and catalogue greatly benefited from the seminal work of Michael FitzGerald and Julia May Boddewyn, whose exhaustive 2006 study *Picasso and American Art* established the groundwork for the present, more focused exhibition. Also critical were the primary documents made available at a number of archives outside the Art Institute, including, most particularly, the Arts Club of Chicago, the Newberry Library, the Renaissance Society, and Skidmore, Owings & Merrill, as well as the reviews by many of the colorful critics who have written for Chicago's newspapers. I wish also to thank Jack Brown and the dedicated staff of the Ryerson and Burnham Libraries, especially Bart Ryckbosch and Deborah Webb in Archives; as well as Karen Widi, Manager, Library, Records, and Information Services at SOM. I am particularly grateful to Marissa Baker and Marin Sarvé-Tarr, both of whom tirelessly combed through historical materials to help assemble the chronology that follows. Finally, for their expertise, knowledge, and inspiration, I would like to thank Vivian Barnett, J. P. Cole, Adam Gopnik, Celia Hilliard, Mark Krisko, and Diana Picasso.

The exhibition and catalogue are built upon the strong foundations laid down by the many talented people who have contributed to a future online scholarly catalogue of the museum's collection of works by Picasso: Renée DeVoe Mertz in the department of Medieval to Modern European Painting and Sculpture, and Diane Miliotes and Kathleen Thornton, formerly in the department; Frank Zuccari, Francesca Casadio, and Allison Langley, Paintings Conservation; Suzie Schnepp, Objects Conservation; and Emily Vokt Ziemba, Mark Pascale, Suzanne Folds McCullagh, Harriet Stratis, and Kristi Dahm, Department of Prints and Drawings. I am grateful for their sustained curiosity and dedicated and resourceful research, some of which is highlighted in a special section of the exhibition. Additional thanks go to Marilyn McCully and Michael Raeburn for their sage insights and suggestions about the research on our works.

At its heart, *Picasso and Chicago* has benefited from the extraordinary support and counsel of Douglas Druick, President and Eloise W. Martin Director. Equally important was the guidance of Dorothy Schroeder, Vice President for Exhibitions and Museum Administration. Special thanks are also due Elizabeth Hurley and George Martin; Julie Getzels and Troy Klyber; Jeanne Ladd; Martha Tedeschi; and David Thurm.

In the Department of Medieval to Modern European Painting and Sculpture, Jennifer Paoletti is gratefully recognized for the intelligence, efficiency, and attention to detail that she brought to each aspect of the project. Thanks as well to Elizabeth McGoey, Adrienne Jeske, Robert Burnier, and Aza Quinn-Brauner, who helped in all aspects of the presentation of the exhibition. And for their collegial support, I also thank Sylvain Bellenger, chair of the department, as well as Katharine Baetjer, Geraldine Banik, Jennifer Cohen, Marie-Caroline Dihu, Gloria Groom, Jane Neet, Allison Perelman, Jill Shaw, Eve Straussman-Pflanzer, Stephanie Strother, Genevieve Westerby, and Martha Wolff.

Likewise, in the department of Prints and Drawings, I am extremely grateful for the efforts of my colleagues dedicated to the cataloguing, treatment, matting, framing, and presentation of all the Picasso works on paper. For their commitment and expertise, I am indebted to Suzanne Folds McCullagh, Mark Pascale, Kristi Dahm, Kimberly Nichols, Christine Conniff-O'Shea, Margaret Sears, Harriet Stratis, and Emily Vokt Ziemba. I am

equally grateful to Suzanne Karr Schmidt for her work to make an electronic version of our specially bound and embellished copy of Picasso's *Unknown Masterpiece* (1931) available for our exhibition. Thanks as well to Christine Fabian; Frank Zuccari, Allison Langley, Kirk Vuillemot, and Charles Pietraszewski; and Suzie Schnepp for their care and preparation of the illustrated book, paintings, and sculpture in the show.

The Publications Department made the production of this catalogue a true pleasure, and I am grateful to Robert V. Sharp, Executive Director, not only for his enthusiasm for this publication but also for his sensitive editing of the manuscript. Thanks as well to Sarah Guernsey, Lauren Makholm, Wilson McBee, Bryan Miller, and Joseph Mohan for their essential parts in the careful management and production of this book. Jeff Wonderland, as always, has contributed a fresh and elegant design.

For the design and construction of the installation, for the wall texts and labels (not just in our main exhibition space, but throughout the museum in the ten Picasso-related installations), and for the multitude of exhibition-related materials and outreach, I thank Jeff Wonderland and his staff in Graphics; Bernice Chu and Markus Dohner in Design and Construction; Gordon Montgomery, Erin Hogan, Nora Gainer, Chai Lee, and Gary Stoppelman in Marketing and Public Affairs; and David Stark and the department of Museum Education. The registrarial team, led by Jennifer Draffen, with Darrell Green, has expertly coordinated the logistics of our loans. Thanks also to Sam Quigley, Elizabeth Neely, and Carissa Kowalski Dougherty in Digital Information and Access for our electronic needs, and to Bill Foster for his help in presenting our conservation research in the exhibition.

I would like to thank all my colleagues in the curatorial departments and library who devised imaginative and lively permanent-collection presentations for the larger Picasso celebration in the museum: Kathleen Bickford Berzock, African Art and Indian Art of the Americas; Jack Brown, Ryerson and Burnham Libraries; Alison Fisher, Architecture and Design; Gloria Groom and Eve Straussman-Pflanzer, Medieval to Modern European Painting and Sculpture; Karen Manchester, Ancient and Byzantine Art; Sarah Kelly Oehler, American Art; Mark Pascale, Prints and Drawings; and Matthew Witkovsky and Elizabeth Siegel, Photography.

Finally, all of us are extremely grateful to Timothy F. Rub, George D. Widener Director, and his staff at the Philadelphia Museum of Art for allowing three precious works by Picasso from their own important collection to come to Chicago as loans during the run of our show. The opportunity to see our cherished collection of modern art—especially in the anniversary year of the Armory Show—engaged in a fresh and lively conversation with new works by Picasso is truly a gift to our city.

STEPHANIE D'ALESSANDRO

Gary C. and Frances Comer Curator of Modern Art
The Art Institute of Chicago

PICASSO NOT IN AMERICA

ADAM GOPNIK

Although Picasso never came to America, or to Chicago, the *idea* of America—of the American city, the American mind, and the American ambition—is, in complicated ways, central to his work. Gerald Murphy, the expatriate original of Scott Fitzgerald's Dick Diver (and, for a few years at least, a visionary American pop artist), told the writer Calvin Tomkins once about Picasso's large collection of Lincoln memorabilia, which, Murphy said, Picasso kept locked in a box. "That is the real American elegance," Picasso told Murphy, of Lincoln's gaunt, folk-art face. This story is oddly hard to confirm. Murphy was no fable-maker, and yet, while one can't quite see the point of his *inventing* so ornate a tale, no other record of it seems to exist. Yet it resonates because it was a plausible story to tell. It fits. That Picasso would keep a collection devoted to, say, a nineteenth-century *British* statesman—perhaps William Gladstone—sounds absurd. But that Picasso was naturally drawn to the glamour, the energy, the idea of America—to the authenticity and stark modernity of the address that those Mathew Brady photos of Lincoln announce—seems right. It is, one might say, no accident that Picasso's portrait of that echt-American Gertrude Stein (1905–06; the Metropolitan Museum of Art, New York), with its strict determination not to do it pretty, is where modern portrait making begins.

Yet Picasso's idea of America is a bounded one. The art historian William Rubin, who knew him well, once said that Picasso's ideas of America began and ended with lower Manhattan and Hollywood: that that was his complete, somewhat Steinbergian map of the New World. In Picasso's work, the fascination—at times, almost an infatuation—with America shows up in several different forms. First, America represented the shining stable where a new age was being born. This is perhaps most movingly expressed in the way that, at the moment when he and Georges Braque were inventing Cubism, they liked to call each other "Orville" and "Wilbur." They saw themselves as the Wright brothers of painting, pushing towards a higher horizon. Nor was the imagery accidental, or occasional: the idea of the intertwining of American aviation and the Parisian avant-garde was central to the purposes of Cubism: "Our Future Is in the Air" one Picasso collage announces (1912; private collection).

More subtly, the move towards this "Americanness" marked a moment when Paris was beginning to retreat from its place as the city of the Baudelairean flaneur, the ultimate modern city, to become the more nostalgia-seeped city we know now, the place of garrets and rooftops that looked west across the ocean, towards a more authentically technological modernism of new machines and tall buildings. This romantic vision of America came to a head in the legendary costumes Picasso designed for the Cocteau-Satie ballet *Parade* (1917), where his imagery of the skyscraper and the airplane mingled with the old European notion of the circus to make a work that was at once playfully "modern" and nostalgic, American and European both. (The union of the imag-

ery of the skyscraper and the airplane was a signal one of the twentieth century; indeed, the fatal joining of the two marked the true end of the twentieth century and the ominous birth of the twenty-first.)

The rebound outwards came later, as Picasso's painting and sculpture changed the directions of American art. Ironically, this happened mostly after the World War II, at the time when Picasso's official ideology, through his connection to the French Communist Party, took an explicitly anti-American turn. It produced the propaganda picture *Massacre in Korea* (1951; Musée National Picasso, Paris), a kind of kitsch version of *Guernica*. Yet as Picasso officially turned away from America, American art turned more towards him. Pollock and Gorky, David Smith and Richard Serra, all ate up Picasso in order to become themselves. That intensity of painterly interest in Picasso continues to affect American art by attraction and repulsion alike. (The painters of the second generation of Abstract Expressionism deliberately embraced Matisse's gravity-denying lightness of touch and transparency of color as an antidote to Picassoid weight and heavy breathing.)

But it wasn't just artists who cared. At the very moment of seeming to repel American attention, Picasso became a kind of American himself: almost, one might say, the fertility symbol of *Life* magazine. Constantly photographed for its pages, represented as the striped-shirt satyr of the Riviera, or as a magician drawing with light while stripped to the waist, it was this Picasso whom the American masses came to know. And it is this Picasso who still resonates in American pop imagination, as one sees in the late sixties movie *The Picasso Summer* with Albert Finney as a young painter who goes in search of the Spanish painter to validate his dreams, with a lush score by Michel Legrand and kitsch animation by the DePatie-Freleng studio. It is also the Picasso who is memorialized in Paul McCartney's 1973 song "Picasso's Last Words." Though this image of Picasso might provoke a mordant snicker in the modish, it has pop art integrity of its own: that striped shirt, that bare torso, *registers*. (If there were no pop image of Picasso, the same people who mock this one would point to it as the inability of American culture to deal at all with high art.)

In a certain sense, it was this "pop" Picasso who was asked, even begged, in the mid-sixties, to make a monumental public sculpture for Chicago. Picasso was no longer a fashionable artist in the mid-sixties—indeed, avant-garde taste had (perhaps stupidly) passed Picasso by, and Claes Oldenburg's mock-monuments and Richard Serra's site-specific works were already beginning to become the avant-garde ideal of public art. But just as Picasso had an idea of America, America had an idea of Picasso: as the one artist who had both modernist credentials and inarguable authority, even among those who were still wary about the excesses or absurdities of modernism. ("Well, Picasso can really draw," was the way my grandfather put it, and the Blue Period and the Rose Period were there to reassure the baffled that he could do the normal thing if he really wanted to.) It seems, perhaps, no accident that the design Picasso chose for his monumental sculpture, though certainly not site specific to Chicago, does derive its central form—that open, equine mask-head of a woman—from one of those costume designs for his pro-American enterprise *Parade*. His biggest and most conclusive American statement derives from his most evanescent (and now vanished) imaginary American celebration. Was it tongue in cheek wit on an enormous scale that led him to that prototype? In even the most public and colossal gestures Picasso made towards America, there do seem to be buried levels of puns and allusions and self-reference. He codes America in improbable and personal ways in art that often seems merely mass-produced.

Whatever its merits as public sculpture—and our tastes have turned back towards the figurative and the personal style it represents—it is an act of self-assertion, and it is in that arena of self-assertion that Picasso and Chicago really meet. Nothing, in a sense, could be more fitting than that this giant memorial of Picasso's complicated, serial infatuation (and disgust) with a distant dream America would be known now not as the Chicago Horse, or the Horse Angel, or the Head-with-Web. It is, simply, "the Picasso," that singular article registering the singularity of the finished art.

100 YEARS: PICASSO AND CHICAGO

STEPHANIE D'ALESSANDRO

This history recounts how Pablo Picasso's art was experienced and received in Chicago through the exhibitions mounted by the city's various museums and arts organizations and through the acquisitions of Picasso's work made by the city's major cultural institutions and its earliest promoters of modern art. At the same time, this chronology highlights important moments of the artist's career when they overlap with the city's history and artworks in Chicago collections today. Careful readers will also note the changing face of Picasso's reputation, as he moved from being a relatively unknown figure to one of the most celebrated artists of the twentieth century.[1]

1913

The *International Exhibition of Modern Art*, better known as the Armory Show, which has been organized by the Association of American Painters and Sculptors, opens at the Art Institute of Chicago on March 24 and runs through April 14. This exhibition is the most comprehensive presentation of European modern art held in the United States to date, and it attracts nearly 200,000 visitors in Chicago. Seven paintings and drawings by "Paul Picasso," who is relatively unknown to American audiences, are presented as part of the organizers' effort to introduce recent artistic "forces" in Europe. In the press, Picasso is identified as the leader of the Cubists, and discussion focuses on deciphering his abstract works. Harriet Monroe, critic for the *Chicago Daily Tribune*, judges Picasso's work as too intellectual: "Their [the Cubists'] art, if it is art, would seem to be in an experimental stage, and time alone can determine whether it will lead to anything. Meantime, one can amuse oneself by . . . wondering why Picasso's lady [*Woman with Mustard Pot*, 1909-10] is so contorted on contemplating her pot of mustard."[2]

As the only museum venue for the Armory Show—which had been shown the month before in New York at the 69th Regiment Armory and would open in Boston the month following at a private arts club—the Art Institute has the distinction of becoming the first American art museum to present the work of Picasso, who is thirty-one at the time of the exhibition in Chicago (fig. 1).

In New York, *Head of a Woman (Fernande)* (fall 1909; pl. 22) is included in the exhibition; owned by Alfred Stieglitz (1864–1946), the well-known photographer, dealer, and legendary promoter of modern art in the United States, this sculpture will later become part of his gift to the Art Institute.

Ambroise Vollard (1866–1939), the renowned dealer and publisher who gave Picasso his first French exhibition in 1901, purchases from the artist the printing plates for a group of 1904-05 circus-related etchings and drypoints; Vollard has the plates steel-faced to preserve them for continued use and reprints them with master printer Louis Fort under the title *The Saltimbanques* (see pl. 8). This will be the first of many opportunities in which Vollard publishes groups of Picasso's prints, including the one hundred etchings known collectively today as the Vollard Suite (1930–37; see pls. 52 and 53).

1914

Arthur Jerome Eddy (1859–1920), a Chicago attorney, collector, critic, and one of the instigators for the Art Institute's presentation of the Armory Show, publishes *Cubists and Post-Impressionism*, considered the first publication in the United States to promote modern art. Eddy champions the vitality and invention of modernism, with specific attention to Cubism, and cites the work of Picasso as a prime example

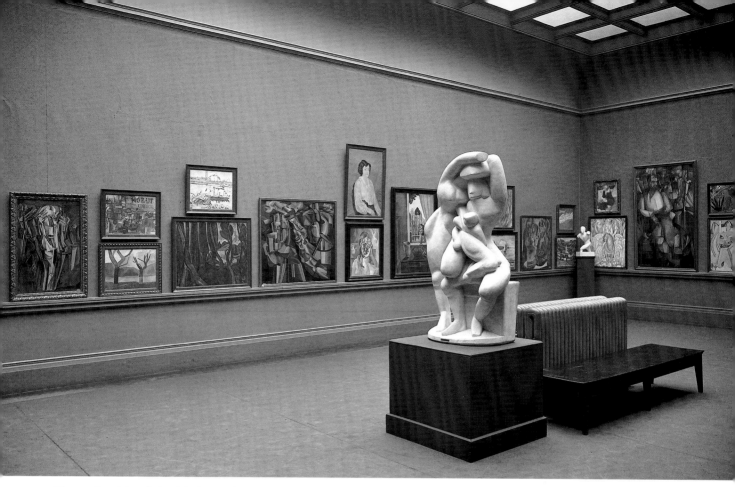

Figure 1. One of the galleries of the Armory Show as installed at the Art Institute of Chicago in March 1913; on the left wall are three of the seven works by Picasso included in the exhibition: *Landscape with Two Trees* (1907–08; Philadelphia Museum of Art); *Madame Soler* (1903; Pinakothek der Moderne, Munich); and *Woman with Mustard Pot* (1909–10; Gemeentemuseum, The Hague).

of modern art's dynamism: "One has but to look at a series of Picasso's works to see how often and radically he has changed his style in these ten years from drawing and painting with great facility and success in Impressionistic and Neo-Impressionistic manner to the most abstract Cubism; what he will be doing two years hence, no one can predict, save that, judging by the past, he will not be painting Cubist pictures."[3] One work by Picasso in Eddy's own collection, *Old Woman (Woman with Gloves)* (1901; pl. 3), is reproduced in the book.

1915

The Renaissance Society at the University of Chicago is founded. While its initial programs are lectures, the Society will start mounting exhibitions in 1918. Over the years, it will

present twenty-one exhibitions that include Picasso's work, especially in the 1930s with the assistance of Chester H. Johnson, the Chicago gallery owner known as a "persuasive and patient defender of new tendencies of art," and again in the 1950s, drawing on the private collections in the city.[4]

1916

The Arts Club of Chicago is founded as a private club to promote modern art in the city. Rue Winterbotham Carpenter (1876–1931), wife of composer John Alden Carpenter and president of the Arts Club from 1918 until her death, proves herself to be an innovative and bold champion of twentieth-century art. She will exercise a profound influence in advancing the Club as one of the city's premiere arts organizations. During her tenure, Carpenter devotes five solo exhibitions to Picasso, and his work is included in five additional group shows.

1917

Picasso works on the sets and costumes for *Parade*, composed

for Serge Diaghilev's Ballet Russes, with music by Erik Satie, a one-act scenario by Jean Cocteau, and choreography by Léonide Massine (see pl. 37). The ballet opens on Friday, May 18, at the Théâtre du Châtelet in Paris, to riotous reviews. It is during this period that the artist also meets the ballerina Olga Koklova, a member of the Ballet Russes who dances in the premiere of *Parade* and whom he will marry the next year.

1921

Chicago businessman Joseph Winterbotham (1852–1925), father of Rue Winterbotham Carpenter, makes a bold proposal to the Art Institute to assemble a collection of modern art. Presenting an initial gift of $50,000, Winterbotham stipulates that the money should be invested and from the interest that accrues, the museum should build a collection of thirty-five European modern paintings. Once the first group numbers thirty-five, any of these paintings could then be sold or exchanged to ensure that the collection "as time goes on, is [dedicated] toward superior works of art and of greater merit and continuous improvement."[5] In 1940 Picasso's *Head of a Woman* (summer 1909; pl. 19), once owned by the great collectors and Picasso supporters Leo and Gertrude Stein, will be acquired for the collection. By the 1930s Winterbotham will have drawings by Picasso in his personal collection as well.

Picasso's first son, Paulo, is born on February 4. The artist begins a series of paintings devoted to the theme of a mother and child. The largest of the paintings in this group is *Mother and Child* (1921; pl. 41), which will be acquired by the Art Institute in 1954.

A Selected Group of American and French Paintings, organized by Forbes Watson, opens at the Arts Club opens in November. One of the leading art critics in America in the 1920s, Watson includes two works by Picasso in the exhibition.

1922

The collection of the late Arthur Jerome Eddy is shown at the Art Institute (September 19–October 22), including his sole canvas by Picasso, *Old Woman (Woman with Gloves)*(1901; pl. 3).

1923

Businessman Robert Allerton (1873–1964)—an Art Institute trustee since 1918 and the generous donor of nearly nine hundred works of art to the museum—begins acquiring drawings by Picasso with the intention of donating them to the museum. Allerton's first acquisitions, including *Sketches of a Young*

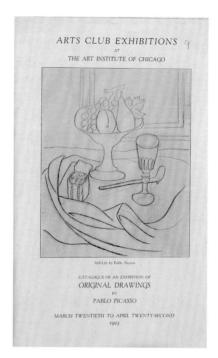

Figure 2. Cover of the 1923 Arts Club exhibition catalogue.

Woman and a Man (1904) and *Study of a Seated Man* (1905; pl. 13), are also the museum's first works by Picasso, given in 1923 and 1924, respectively. Allerton will purchase the first of these, along with *Peasant Girls from Andorra* (late summer 1906; pl. 10), which he will give to the Art Institute a few years later, from the Albert Roullier Galleries, one of the foremost early print dealers and proponents of the graphic arts in Chicago.

The Arts Club, which has been presenting exhibitions for the last year at the Art Institute and will continue to do so until 1927, organizes a show of fifty-three works on paper by Picasso dating from 1907 to 1921 (fig. 2). *Original Drawings by Pablo Picasso* (March 20–April 22) is the first solo exhibition devoted to the artist in the city; it is also the first exhibition devoted solely to the artist in a non-commercial space in the United States.

Picasso has a hand in the installation of this show, stipulating to the organizers that all his drawings are "not to be framed, but put under a glass bordered with a little band of paper . . . mounted on a piece of paper (or cardboard) larger than the drawing itself." Light and dark drawings are to have corresponding white, cream, or tinted mounts. Furthermore, the artist directs the show's organizers "to intermingle black drawings with acquarelles and other coloured drawings."[6]

The exhibition receives much attention. Blanche C. Matthias, reporter for the *Chicago Herald and Examiner*, writes, "Picasso never fails to stir the spectator. The emotion aroused may be one of irritability . . . or it may be pleasurable sensation if one is able to overcome the domination of hackneyed subject matter, and consider the plastic significance of the painting or drawing seen. . . . [He] has given himself up to the enjoyment of stirring the speculative and intellectual emotions rather than concerning himself with representative portrayals."[7] The Club acquires the monumental chalk drawing *Head of a Woman* (1922; pl. 44) from the exhibition.

1924

Paintings by Pablo Picasso, an Arts Club exhibition at the Art Institute, opens on December 18 and runs through January 21. The sixteen paintings, which date from the period 1920–23, are introduced with an essay by the English critic Clive Bell, who describes Picasso as "one of the most inventive minds in Europe."[8] According to Alice Roullier, chair of the club's Exhibition Committee from 1918 to 1941, efforts are made by club members to acquire a painting from the exhibition.

1926

A Group of Paintings by Various Modern Artists is presented by the Arts Club at the Art Institute in March; one work by Picasso, in the collection of American artist Arthur B. Davies, is included. Picasso's work is also shown in the Art Institute's *Sixth International Water Color Exhibition* in May; over the next fifteen years, he will be included in eight annual exhibitions.

As a memorial to his second wife, Helen Birch (1883–1925), Chicago-born painter and modern art collector Frederic Clay Bartlett (1873–1953) presents the Art Institute with their collection of modern European paintings, which includes Picasso's *Old Guitarist* (late 1903–early 1904; pl. 4). In an exhibition of the Birch Bartlett collection the previous year, the museum's catalogue described Picasso's leadership in modern art and his innovation of form, and explained his stylistic variations not as stages but rather, in the artist's own words, as "different motives [that] require different methods of expression."[9]

The Helen Birch Bartlett Memorial Collection is permanently installed in the museum in May; the continued display of a whole collection of avant-garde art in an American museum is completely unprecedented, and with this acquisition, the Art Institute becomes the first museum in the United States to have Picasso's work on continual display.

1927

Picasso meets Marie-Thérèse Walter in front of the Galeries Lafayette in Paris; she is seventeen years old and will soon become his lover. Walter will recall how the artist introduced himself by saying: "Mademoiselle, you have an interesting face. I would like to make your portrait. I am Picasso."[10] He would make many portraits of her over their nine years together (see pls. 46 and 55). One portrait from 1931 still in the artist's possession twenty years later would be given to the Art Institute in 1957 by Picasso's American dealers, former Chicagoans Daniel and Eleanore Saidenberg (pl. 56).

1928

Original Drawings by Pablo Picasso opens at the Arts Club on February 29 and runs through March 13.

The Renaissance Society presents *Modern French Painting and Sculpture* in March; the show includes one painting by Picasso, a "dynamic yellow and black 'Supper Party.'"[11]

1929

Loan Exhibition of Modern Paintings: Privately Owned by Chicagoans opens at the Arts Club in January; it includes one work by Picasso. In February the club will also show the work of the artist in *Some Modern Paintings*, on loan from Paul Rosenberg, Picasso's dealer from 1918 to 1940.

In the spring, two of Picasso's works are presented in the Art Institute's *European Paintings from the Carnegie International Exhibitions*.

The Renaissance Society hosts a lecture in December by artist Frances Foy Dahlstrom entitled "Picasso, Matisse, and the French Tradition."

1930

In February the Renaissance Society presents an exhibition of modern French paintings. *Woman with a Helmet of Hair* (1904; pl. 6), recently acquired and loaned by Kate and Walter Brewster, receives much attention. This painting will later be given by them to the Art Institute in 1950. Agnes C. Gale of the *Hyde Park Herald* notes the fruitful comparisons that can emerge from juxtaposing the work of modern painters with old masters such as El Greco.[12] Picasso's work will also be included in two additional exhibitions this year, supported by local loans.

The Arts Club opens *Paintings by Picasso* on March 16; it will run through April 9. Comprising fifteen paintings, the exhibition includes five loans from Chicago collectors and institutions. Earlier in the year four works by Picasso are presented in *Loan Exhibition of Modern Drawings and Sculpture: Privately Owned by Chicagoans*. In November the Arts Club opens *Exhibition of Original Drawings by Pablo Picasso*, a show of eighteen drawings (1905–28) from the artist, plus one local loan.

1931

The Renaissance Society hosts *Some Modern Primitives: International Exhibition of Paintings and Prints*; fifteen drawings and paintings are by Picasso. Earlier the institution presents its annual exhibition of modern French painting with one work from 1919 by Picasso.

1932

Paintings by Pablo Picasso, with over thirty works that span his career, is organized by playwright and collector Mary Hoyt Wiborg for the Arts Club (January 4–16). Eleanor Jewett of the *Chicago Daily Tribune* warns viewers to prepare themselves for a group of paintings that is "extraordinary for its conscious ugliness. The single canvas, which is admirable in drawing and coloring is indecent…. For the rest you will find several cubisticly [*sic*] inclined portrait heads, ghastly in color, awkward in feature."[13]

On April 6 the Art Institute's Antiquarian Society shows the *Mrs. L. L. Coburn Collection of Modern Painting and Water Colors*, which runs through October 9. Over sixty primarily Impressionist and Post-Impressionist works are presented, including Picasso's *On the Upper Deck* (1901).

Two group exhibitions at the Renaissance Society include six works by the artist, four from private Chicago collectors.

The Art Institute's Curator of Painting and Sculpture, Daniel Catton Rich, delivers the lecture "Picasso in the Present Tense" on April 20 at the Oriental Institute at the University of Chicago. Rich will later serve as the museum's Director of Fine Arts from 1938 to 1958.

1933

Pure Line Drawing—From the Greek to the Modern opens at the Renaissance Society with two drawings by Picasso loaned from local collectors.

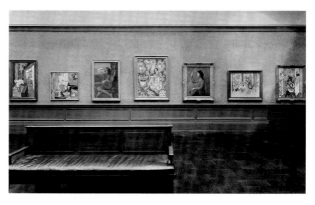

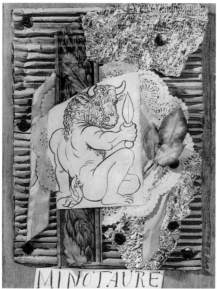

Figure 3. View of the installation of Picasso's works in *A Century of Progress International Exposition*, Chicago, 1933.

Figure 4. Cover for the first issue of *Minotaure*, 1933, designed by Picasso. The Art Institute of Chicago, Ryerson and Burnham Libraries.

The Art Institute mounts a celebratory exhibition for the 1933 World's Fair, *A Century of Progress International Exposition* (fig. 3), to recognize the city's centennial. This enormous exhibition, with over one thousand works spanning early Renaissance to modern art, includes twenty works by Picasso, nine from Chicago collections. Attendance at the exhibition is overwhelming and due to its enormous popularity, a second exhibition of works (also including Picasso) in honor of the Century of Progress will take place the following year as well.

Three exhibitions at the Arts Club include ten paintings and drawings by the artist.

Picasso designs the cover for the first issue of publisher Albert Skira's art magazine *Minotaure* (fig. 4). A creature from Greek mythology with the head of a bull and the body of a man, the minotaur becomes a frequent figure for the artist at this time (see pls. 50–52 and 54), representing the inner turmoil of his personal life (caught between Olga and Marie-Thérèse) and the growing political and social upheaval of his homeland. The minotaur would even come to symbolize Picasso himself in his works.

1934

Abstract Painting by Four Twentieth Century Painters: Picasso—Gris—Braque—Léger is held at the Renaissance Society; the exhibition includes thirteen works by Picasso, one from a private collection in Chicago. Later in the year, a selection of works by twentieth-century artists organized by curator and writer James Johnson Sweeney is shown with four works by Picasso. Sweeney asks the society director not to use the word "abstraction" in the exhibition title as "it frightens people, seemingly—or at least puts them frequently in an antipathetic attitude before they ever look at the canvas."[14]

The home of Elizabeth "Bobsy" Goodspeed (later Mrs. Gilbert W. Chapman, 1893–1980), the third president of the Arts Club, and her husband, Charles, is the center of much social and artistic interest in the city; in November they host the visit of early Picasso supporters Gertrude Stein (1874–1946) and Alice B. Toklas (1877–1967) to Chicago (see fig. 5).

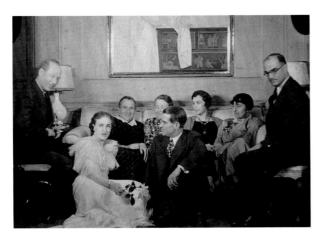

Figure 5. A party at the home of Charles and Elizabeth "Bobsy" Goodspeed: *left to right*, Charles B. Goodspeed; Bobsy Goodspeed; Gertrude Stein; the *Chicago Tribune* literary critic Fanny Butcher; Butcher's husband, Richard Bokum; Chicago gallery owner Alice Roullier; Alice B. Toklas; and American novelist and playwright Thornton Wilder, then on the faculty of the University of Chicago.

Modern Paintings from the Collection of Mr. Earl Horter of Philadelphia opens at the Arts Club. Two works from this exhibition—*Bust of a Woman* (late 1909; pl. 21) and *Daniel-Henry Kahnweiler* (fall 1910; pl. 28), the latter of which will be acquired this year by the Goodspeeds—will subsequently become part of the Art Institute's collection. Later in the year *Léonide Massine Collection of Modern Paintings* is held at the Arts Club; two drawings from this presentation would later enter Chicago private collections.

1935

In April the Arts Club presents the collection of dealer Sidney Janis, which features six works by Picasso, including *Painter and Model* (1928; Museum of Modern Art, New York).

A *Summer Loan Exhibition of Paintings and Sculpture* is mounted at the Art Institute. The show highlights *Crazy Woman with Cats* (early summer 1901; pl. 2), which has recently been acquired by Colonel Robert R. and Amy McCormick and will be given to the museum in 1942. The painting is of particular significance as it was among those Picasso showed in his first exhibition in Paris, with Ambroise Vollard, in 1901.

1936

The Arts Club presents two exhibitions that feature works by Picasso, including a tapestry commissioned by Marie Cuttoli, the important early patron of modernist textiles—a work that is described by critic Eleanor Jewett as "a distinctly neurotic composition"—and two drawings from the collection of Joseph Winterbotham.[15]

Picasso meets the photographer Dora Maar. Over the next years of their relationship, the artist will make her the subject of numerous portraits. Picasso paints Maar in many different guises (see pl. 58), including the Weeping Woman (see pls. 59–62), explaining, "For years I've painted her in tortured forms, not through sadism, and not with pleasure, either; just obeying a vision that forced itself on me."[16]

1937

Eighteen paintings and drawings by Picasso from the Walter P. Chrysler collection are presented by the Arts Club in January.

In April the Renaissance Society mounts *International Moderns* with a *papier collé* by Picasso described by a writer for *Townsfolk* as "delightful." The writer continues: "It is good to remember here that the cubists themselves were the first to admit

that a *papier collé* was something anyone gifted with a native sensibility could produce."[17]

1938

The Arts Club hosts a loan exhibition of modern paintings and drawings from private collections in Chicago in November; fourteen works by Picasso are presented, including a painting of Daniel-Henry Kahnweiler (1884–1979), one of Picasso's earliest dealers (pl. 28), which is lent by Bobsy Goodspeed and later given to the Art Institute.

1939

Exhibition of Drawings by Pablo Picasso Loaned by Mr. Walter P. Chrysler, Jr., New York is held at the Arts Club in January with twenty-four works ranging in date from 1904 to 1933.

Through the American Artists' Congress, the Arts Club is a venue for the United States tour of Picasso's masterpiece *Guernica* (fig. 6) and fifty-nine related works, to benefit the Spanish Relief Campaign. Rental fees and proceeds from catalogue sales are sent to the artist for donation to the relief fund. The exhibition, which opens on October 2, lasts for a week. French art critic Georges Duthuit speaks on "Pablo Picasso, Witness of the European Tragedy."

Chicago critic Eleanor Jewett writes in the *Sunday Tribune,* "Picasso has made his name. He is known the world over as the world's [shall we say?] first modernist; not, you understand, in point of time, but in contemporary rating. Whatever Picasso does is valuable and important in the eyes of Picasso fans. With the present painting, which is more like an unfinished cartoon in black and white than a painting, Picasso had a heroic theme for subject. . . . Picasso, we are told, was deeply affected by the tragedy. He painted his mural in a passion of anguish. With this in mind, the picture itself becomes the more extraordinary, for where is the anguish in this composition, where terror, horror, pain, shock, havoc, and ruin? Where the noise and weeping of war? Perhaps a modern intelligence keyed to the modern symbolism will find more than the grotesque and fantastic in this painting; for myself, a little war sketch by Goya, just a tiny scrap, six inches of Goya canvas, conveys more of the irresistible, overpowering horror of war than this entire huge fantasy by Picasso."[18]

1940

The Art Institute, in collaboration with the Museum of Modern Art, opens *Picasso: Forty Years of His Art* on February 1; it will run through March 1. Curated by MoMA's curator and director

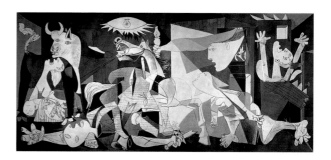

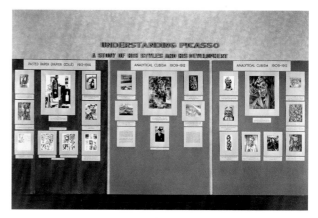

Figure 6. Pablo Picasso, *Guernica*, 1937. Oil on canvas, 349 x 776 cm (137.4 x 305.5 in.). Museo Nacional Centro de Arte Reina Sofía, Madrid.

Figure 7. Installation view of *Understanding Picasso: A Study of His Styles and Development* in the Gallery of Art Interpretation at the Art Institute of Chicago in 1940.

Alfred H. Barr in collaboration with Daniel Catton Rich of the Art Institute, this is the largest exhibition devoted to the artist to date and receives record attendance. Chauncey McCormick, Vice President of the Art Institute's Board of Trustees, recognizes Chicago's critical role in Picasso's American reception, beginning with the Armory Show in 1913 and the Arts Club of Chicago's 1923 solo exhibition and running through the Century of Progress. "One of the most popular rooms in the Art Institute's great . . . exhibition in 1933," he says, "was the one limited to paintings by Picasso and Matisse. This exhibit seemed to settle for Chicago public opinion the then burning question of whether Picasso or Matisse was the greater artist, and Picasso won."[19] Five works from the museum's collection and six from Chicago private collections are featured.

As a supplement to the exhibition, *Understanding Picasso: A Study of His Styles and Development* is presented in the museum's Gallery of Art Interpretation with materials published by Helen F. Mackenzie (see fig. 7). The wide-ranging styles and media explored by the artist are situated with a view to the

art of the past, present, and non-Western cultures as well as the influences of modern life, including advertising and aerial photography.

In April the Arts Club opens *Origins of Modern Art*, which pairs Old Master and modern paintings to examine formal connections; the catalogue foreword is written by Walter Pach, one of the organizers of the 1913 Armory Show. Six works by Picasso are shown, including *Half-Length Female Nude* (fall 1906; pl. 14), which is loaned by Walter P. Chrysler but will later enter the Art Institute's collection through the generosity of prominent Chicago collectors Florene May Schoenborn and Samuel A. Marx in 1959.

1941

Five paintings by Picasso are included in *Masterpieces of French Art*, selected by René Huyghe, curator of paintings at the Louvre. Ranging from 1904 to 1926, the works "present an unforgettable picture of the background and development of modern art."[20]

In November two exhibitions open at the Arts Club: *Private Collection of Mr. and Mrs. Florsheim,* with four works by Picasso; and *Modern Tapestries Designed by Modern Painters* with two works by the artist (*Inspiration* and *The Minotaur*) that were commissioned and executed by Marie Cuttoli.

1943

Twentieth Century French Paintings from the Chester Dale Collection, a group of fifty-two modern paintings, is placed on long-term loan at the Art Institute. In the catalogue for the collection, Daniel Catton Rich celebrates the loan that gives "the great public which annually visits Chicago's art museum an unrivalled opportunity to see and enjoy the masters of contemporary French painting at their distinguished best."[21] Among the works to remain at the museum for nine years are eight Picassos, including *Family of Saltimbanques* (1905; National Gallery of Art, Washington, D.C.).

1944

British artist and writer Wyndham Lewis lectures at the Arts Club on "The Meaning of Ugliness in Rouault, Picasso and Others."

A ballet figure by Picasso is included in *Drawings by Contemporary Artists* at the Renaissance Society in May.

1945

Prints by Picasso opens at the Art Institute on April 20 and runs through September 15. It includes prints from the entire span of the artist's career, including his response to the Spanish Civil War, *The Dream and Lie of Franco* (1937).

In December Picasso begins to focus on lithography in the workshop of Fernand Mourlot in Paris; over the next two months Picasso will produce the dramatic lithographic series *Bull* (1945–46; see pls. 66–69).

1946

The Art Institute presents *14 Paintings by Pablo Picasso and Georges Braque*, made possible by an anonymous loan; three of Picasso's works are also shown in *Drawings Old and New*.

Five works by Picasso are featured in *Variety in Abstraction* at the Arts Club, which runs March 5–30; two come from private Chicago collections. In an article in the *Chicago Daily News*, C. J. Bulliet notes Picasso's *Head* (1909; Museum of Modern Art, New York) as one of many "nuggets from the golden age, when Cubism and its early associate 'isms' were young and vigorous, white hot from the creative brains of their inventors."[22]

In November, the club will present Picasso's painting *La Gommeuse* (1905; private collection) in *Paintings and Drawings from the Josef von Sternberg Collection*, and in December, two works in a traveling exhibition of landscape painting from the Museum of Modern Art, New York.

1947

Picasso's works are included in three exhibitions at the Art Institute: *Modern Illustrated Books: A Collection in the* Making (March–May); *The Winterbotham Collection* (May–June); and *Recent Lithographs by Pablo Picasso* (November).

In the Midi with the artist Françoise Gilot and their newborn son, Claude, Picasso begins to make ceramics at the Madoura pottery, in the workshop of Georges Ramié (see fig. 8). He executes almost two thousand pieces over the next year alone, thus spurring a revitalization of the ceramics industry of Vallauris (see pls. 81–84). He will soon move to a small villa (La Galloise) there, the view from which he will paint in *Villa in Vallauris* (February 4, 1951; pl. 80).

1948

Alfred Stieglitz: His Photographs and His Collection opens at

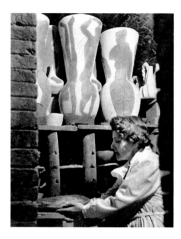

Figure 8. Suzanne Ramié at Madoura Pottery, Vallauris, France, 1952, with an example of *Large Vase with Dancers* (1950; pl. 84) in the background.

the Art Institute; the following year numerous works from this influential promoter of modern art will be accessioned into the museum's collection, including the sculpture *Head of a Woman (Fernande)* and the watercolor *Head of a Woman* (both fall 1909; pls. 22–23).

Picasso meets Hidalgo Arnéra, a master printer. Eight years later they will begin to work together, first on posters for a bullfight and for an exhibition of Vallauris potters, and later on some of the most innovative prints of his career (see pls. 74 and 77).

1949
On April 15, Daniel-Henry Kahnweiler (fig. 9) lectures at the Art Institute on Cubism. Picasso's oldest dealer and a prominent gallery owner in his own right, Kahnweiler was an early and major champion of Cubism, and had already been portrayed in a Cubist style by the artist in the fall of 1910 (pl. 28). His role was so instrumental that it prompted Picasso once to have wondered, "What would have become of us if Kahnweiler had not had good business sense?"[23]

Twentieth-Century Art from the Louise and Walter Arensberg Collection opens at the Art Institute with nearly thirty works by Picasso, including *Female Nude* (1910; Philadelphia Museum of Art).

1951
In April the Department of Art, Northwestern University, presents *Centennial Loan Exhibition: Modern Paintings from Private Collections in the Chicago Area*, which includes three works

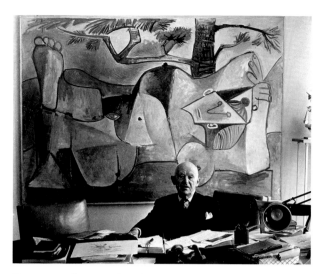

Figure 9. Daniel-Henry Kahnweiler in 1962 in his office at Galerie Louise Leiris, before *Nude under a Pine Tree* (1959; pl. 87), which would be accessioned into the Art Institute's collection three years later. Photograph by Brassaï (Gyula Halász; French, 1899–1984); Musée National Picasso, Paris.

by Picasso. Two come from the collection of Claire Zeisler (1903–1991), a preeminent fiber artist and an important donor to the Art Institute.

The Arts Club includes eight paintings by Picasso (two of which are from local private collections) in *Paintings by Paris Masters: 1941–1951* in the summer. In December it will present a solo exhibition of his lithographs.

In October the Renaissance Society includes three prints by Picasso in its *Contemporary American and European Art from the Collection of Mr. and Mrs. Joseph Randall Shapiro*.

The Art Institute makes the first of a series of nearly annual major acquisitions of Picasso's paintings, by purchase, trade, or gift, under the leadership of Daniel Catton Rich and Katharine Kuh, the museum's first curator of modern painting and sculpture. The first is the abstract *Head* (1927; pl. 49), previously owned by the British Surrealist artist Gordon Onslow-Ford.

1952
The Art Institute acquires *Man with a Pipe (Man with a Mustache, Buttoned Vest, and Pipe)* (1915; pl. 32), the major synthetic Cubist canvas, through the generous gift of collectors Mary and Leigh Block; over the next thirty-some years, the Blocks will make possible the addition of four major paintings by Picasso for the museum.

1953

In January the Art Institute presents *Sculpture of the Twentieth Century,* with four works by Picasso ranging in date from 1909 to 1950. The exhibition, curated by Andrew Carnduff Ritchie, includes one work from a Chicago collection.

The museum acquires *Still Life* (February 4, 1922; pl. 45), once in the collection of Gertrude Stein.

1954

The Renaissance Society opens *Contemporary Paintings, Prints, and Drawings in Memory of Elinor Castle Nef* on March 18; the exhibition will run through April 17, with eleven works on paper by Picasso.

In October the Arts Club presents *Twentieth Century Art Loaned by Members of the Arts Club of Chicago,* with four works by Picasso.

The Art Institute acquires *Mother and Child* (1921; pl. 41), a large-scale maternity image painted in the artist's new classical style.

Picasso begins a series of works devoted to a young girl, Sylvette David (later known as Lydia Corbett). While working on one of the paintings (pl. 78), the painter and sitter are photographed for *Paris Match* (see fig. 10). The painting and the sitter are the subject of much public attention; the canvas will enter the Art Institute's collection the next year.

1955

Abstraction: Background with Blue Cloudy Sky (January 4, 1930; pl. 47), a painting from Picasso's "bone period," is acquired for the Art Institute. On this occasion, the museum's Gallery of Art Interpretation shows *Presenting the Art Institute's Picassos,* focusing on the newly acquired painting.

Earlier in the year, two works by the artist are featured in *Great French Paintings: An Exhibition in Memory of Chauncey McCormick.*

In *As They Like It: An Exhibition of Contemporary Art from the Homes of Five Members in the University* (March 10–24), the Renaissance Society includes an etching by Picasso from the collection of Leon Despres (1908–2009), the noted labor lawyer and civil rights advocate who was also alderman of Chicago's Fifth Ward for twenty years.

Figure 10. Picasso and Sylvette David before *Portrait of Sylvette David* (pl. 78), in a photograph that appeared in the August 14–21, 1954, issue of *Paris Match*.

In October the Arts Club opens *An Exhibition of Cubism on the Occasion of the 40th Anniversary of the Arts Club of Chicago,* with fifteen paintings and drawings by Picasso, about one-third from Chicago collections. In the catalogue, Cubism (and the work of Picasso) is contextualized in the lineage of Post-Impressionism and Fauvism. The club also acquires the 1905 etching *Mother Combing Her Hair* at this time.

1956

The Renaissance Society presents *Students as Collectors: Prints and Drawings from Callot to Picasso* in January, with one drawing by Picasso.

1957

In January the Renaissance Society includes Picasso's *The Dream and Lie of Franco* in *The Condition of Man,* which was arranged by Chicago collector Joseph R. Shapiro, who will also donate works by Picasso to the Art Institute.

May welcomes two major acquisitions to the Art Institute: the sculpture *Flowers in a Vase* (1951; pl. 79), cast from an assemblage of found studio materials, and the Surrealist-era portrait of Marie-Thérèse Walther, *The Red Armchair* (December 16, 1931; pl. 56), the latter the gift of Daniel and Eleanore Saidenberg, Picasso's American representatives. In October

the museum presents *Picasso: 75th Anniversary Exhibition*, organized by the Museum of Modern Art with the support of the Art Institute and the Philadelphia Museum of Art. This is the largest presentation of Picasso's sculpture to date as well as an important presentation of the artist's drawings. Eleven works from the Art Institute are included as well as seven works from private collections in the city. An ancillary exhibition of *Picasso in Photographs* and three print presentations, as well as a lecture by artist Kathleen Blackshear, "Picasso and the Arts of the Past," are also coordinated at the museum. At the University of Chicago, professor Joshua C. Taylor presents an opening lecture in honor of the museum's exhibition.

1958

One painting by Picasso from a Chicago collection is included in the Arts Club's *Surrealism Then and Now*.

1959

The Art Institute acquires *Half-Length Female Nude* (fall 1906; pl. 14), which with its masklike qualities anticipates Picasso's iconic painting of the following year, *Les Demoiselles d'Avignon* (1907; Museum of Modern Art, New York).

Working with Arnéra, Picasso devises a new color linocut process: rather than assign one block for each separate color, he progressively engraves the whole composition on the same block, printing each color after cutting away the image (see pls. 97–100).

1960

Modern Sculpture and Sculptor's Drawings opens at the Renaissance Society in April; one work by Picasso, from a Chicago collection, is featured.

1961

In April the Art Institute presents *Treasures of Chicago Collectors*; ten paintings, sculptures, and drawings by Picasso are included.

1962

Two painted bronze sculptures and one painting by Picasso from Chicago collectors are included in *Wit and Humor in Painting, Sculpture, and the Graphic Arts* at the Arts Club (February 28–March 31).

The Renaissance Society features three works by Picasso in two exhibitions in the spring: *Art to Live With: A Selection from the Joseph Randall Shapiro Student Loan Collection* and *Centennial Exhibition: Hyde Park Collects*.

1963

In April architects for the Chicago Civic Center (today known as the Richard J. Daley Center)—William Hartmann of Skidmore, Owings & Merrill; Charles F. Murphy Sr. of C. F. Murphy Associates; Richard Bennett of Loebl, Schlossman & Bennett—along with administrators of the Art Institute, contact British artist and poet Roland Penrose, who is also a close personal friend and biographer of Picasso. They describe the idea of a monumental sculpture in the new city hall: "When we discussed how this open space or plaza should be designed ultimately, we came to the unanimous conclusion . . . that this is the location for the most important public sculpture in America. We also concluded that we would like to determine if the man who we regard as the world's greatest living artist, would be interested in exploring this problem. We are thinking of Pablo Picasso."[24] Penrose will serve as an insightful and sensitive advocate for the project over the next five years.

The next month, Hartmann writes to Picasso and his second wife, Jacqueline, on behalf of the Chicago group and asks, with the advice of Penrose, to visit the artist in Mougins. A group visits, armed with a model, images of the Art Institute's collection of works by the artist, and an album of photographs of famous Chicagoans. Noting a photograph of Ernest Hemingway, Picasso exclaims "My friend! I taught him everything he knew about bullfighting. Was he from Chicago?"[25]

Photographs of works by Picasso in Chicago collections are also shared as a reminder of his importance in the city. Penrose will later confirm Picasso's interest in the project; it will draw upon ideas the artist has been considering for at least a year or more (see pls. 88–91).

In September the Men's Council of the Art Institute sponsors the exhibition *Chicago Collectors*, with ten works by Picasso on loan from eight private collectors.

1964

In the spring Picasso and Joan Miró discuss their plans for the Civic Center and Brunswick Plaza, respectively.[26] Picasso will begin sketching preliminary studies for the monument and working on a metal maquette (pl. 93).

The Art Institute acquires Picasso's *Jester* (spring 1905; pl. 7), produced at the time of his Rose Period Saltimbanque prints.

1965

Picasso works on the Civic Center sculpture, which is identified as a "head." With deadlines approaching, Hartmann sends

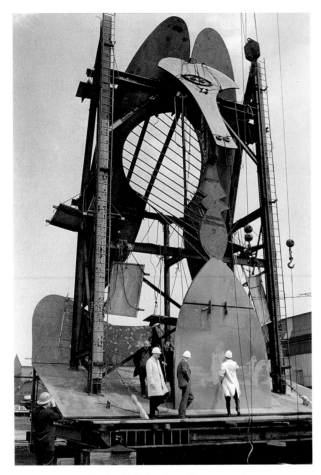

Figure 11. Picasso's *Richard J. Daley Center Sculpture*, under construction in 1965 at U.S. Steel's American Bridge Company plant in Gary, Indiana.

Pablo Picasso: 60 Years of Printmaking opens with ninety prints from the Art Institute's collection representing the artist's career to date. The museum also acquires the monumental *Nude under a Pine Tree* (January 20, 1959; pl. 87).

1966

The Arts Club presents *Drawings 1916/1966*, which includes two works by Picasso.

In the presence of William Hartmann, the artist makes a gift of the sculpture to the city of Chicago; Mayor Richard J. Daley writes to Picasso, "The citizens of Chicago join me in expressing their profound gratitude for this magnificent sculpture which will inspire the life of our city and which will be a source of pleasure to millions of people of all races, creeds, and ethnic origins to love and work or visit here."[29] Picasso also gives the maquette (fig. 12; pl. 93) to the Art Institute; the model and related photographs are placed on view at the museum. In September the news of the monumental sculpture is shared with the public.

1967

Through the Saidenberg Gallery, the Art Institute acquires a group of Picasso's *Standing Women* sculptures (1945–47), under the auspices of the Grant J. Pick Purchase Fund. It also acquires his important drawing *The Minotaur* (June 24, 1933; pl. 51). On August 15 Picasso's sculpture in Daley Plaza is dedicated with thousands of people in attendance (see fig. 13). The work is the first monumental sculpture by Picasso and the first designed expressly for a civic project in the United States. The

Picasso a Chicago White Sox jacket and cap, a Chicago Bears jersey, a straw boater, and a Sioux war bonnet to "stimulate his enthusiasm and curiosity."[27] In May Picasso sends the completed maquette for a monumental sculpture of a woman's head to Chicago. Hartmann sends a telegram to Penrose, "Mougins dame has arrived. Champagne for all!"[28]

A gallery at the Art Institute is used for a special presentation of the work to Mayor Richard J. Daley and the Public Building Commission. Later, once approved, work to prepare scale drawings based on the maquette and other decisions about the specifications necessary for construction are carried out by Skidmore, Owings & Merrill. The fifty-foot-tall work, weighing over one hundred and sixty tons, will be fabricated by the Gary, Indiana, plant of the United States Steel Corporation's American Bridge division (see fig. 11).

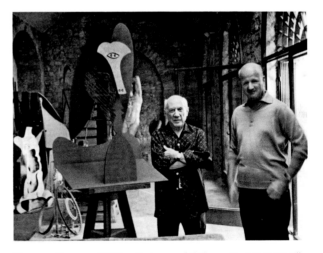

Figure 12. Picasso and William Hartmann of Skidmore, Owings & Merrill with the maquette (pl. 93), August 1966, in Mougins, France.

opening celebration includes a poem written for the occasion and read by Gwendolyn Brooks, a performance by the Chicago Symphony Orchestra, and a message from then-president Lyndon B. Johnson, who writes, "Your new Civic center plaza with its unique and monumental sculpture by one of the acknowledged geniuses of modern art is a fitting addition to a city famous for its creative vitality. Chicago, which gave the world its first skyscraper and America some of our greatest artists and poets, has long recognized that art, beauty, and open space are essential and proper elements in urban living. You have demonstrated once again that Chicago is a city second to none."[30] While there is much public enthusiasm for the sculpture, some initial reaction is also focused on Picasso's Communist connections and his recent (1962) award of the International Lenin Peace Prize (the former Soviet Union's equivalent to the Nobel Peace Prize).

1968

On the occasion of the artist's 85th birthday, the Art Institute presents *Picasso in Chicago: Paintings, Drawings, and Prints from Chicago Collections*; nearly two hundred works are shown. Director Charles C. Cunningham notes in the accompanying catalogue, "[I]n few cities in the world has the work of Picasso been collected so extensively as in Chicago," adding that the exhibition "signals the homage that Chicagoans have paid to the greatest artist of our century."[31] Curator A. James Speyer writes that "The inauguration of the new civic sculpture suggests—demands—the appropriateness of a local tribute to the world's most distinguished living artist in his eighty-sixth year."[32]

William Hartmann visits Picasso and shares with him the catalogue for the exhibition. The artist reviews the publication, and delighted to find *Mother and Child* in the collection of the Art Institute, asks Hartmann to wait. Picasso reappears with a narrow rectangular canvas, which would prove to be a fragment of painting (pl. 41a) to bring back to the Art Institute. Additionally, Picasso makes a gift of twelve studies for the Chicago sculpture (1964).

Later in the year the Art Institute acquires the painting *Still Life before the Window* (1934). It also hosts *Painting in France, 1900–1967* with three works by the artist from the collection of the Musée National d'Art Moderne, including his curtain for *Parade* (1917). It also presents *Picasso: 347 Engravings*, a presentation of prints made from March 16 to October 5, 1968, in Mougins; the exhibition is simultaneously shown at Galerie Louise Leiris in Paris. Art Institute trustee William Hartmann arranges the show in collaboration with museum curator Harold Joachim.

The Arts Club presents *Jewelry by Contemporary Painters and Sculptors*, which includes a pendant by Picasso.

1969

Masterpieces from Private Collections in Chicago opens at the Art Institute, with one painting by Picasso.

1970

In June the Art Institute mounts *The Grant J. Pick Collection*, which includes eleven works by the artist.

1973

Picasso dies at the age of ninety-one.

The Art Institute presents a five-part lecture series on *Picasso: Artist of the Twentieth Century*, which examines his art as autobiographical data. Three exhibitions presented in the fall, *Drawings from the Kröller-Müller National Museum, Otterlo*; *Major Works from the Collection of Nathan Cummings*; and *Twentieth-Century Prints, Part V: The Forties* feature a number of works by the artist.

1974

Impressionist and Post-Impressionist Paintings from the USSR is shown at the Art Institute; it includes six works by Picasso that were formerly owned by the important early collectors Ivan Morosov and Sergei Shchukin, but that have been, since 1917, in the Soviet State collections.

1975

The Arts Club presents *The Horse as Motif: 1200 B.C.—1966 A.D.*, which includes an etching by Picasso. Later in the year, the club features four works by the artist in *Sixty Years on the Arts Club Stage*; two of these are from Chicago collections.

1977

In May three works by Picasso (1909–1933) are shown in *French Drawings from the Art Institute of Chicago: Watteau to Picasso*. In November Rosamond Bernier, critic and cofounder of *L'Oeil*, speaks on Picasso.

1980

The Smart Museum of Art, founded six years earlier, presents European and American Cubism with works by Picasso; over the years, the institution will present six exhibitions that feature the artist's work.

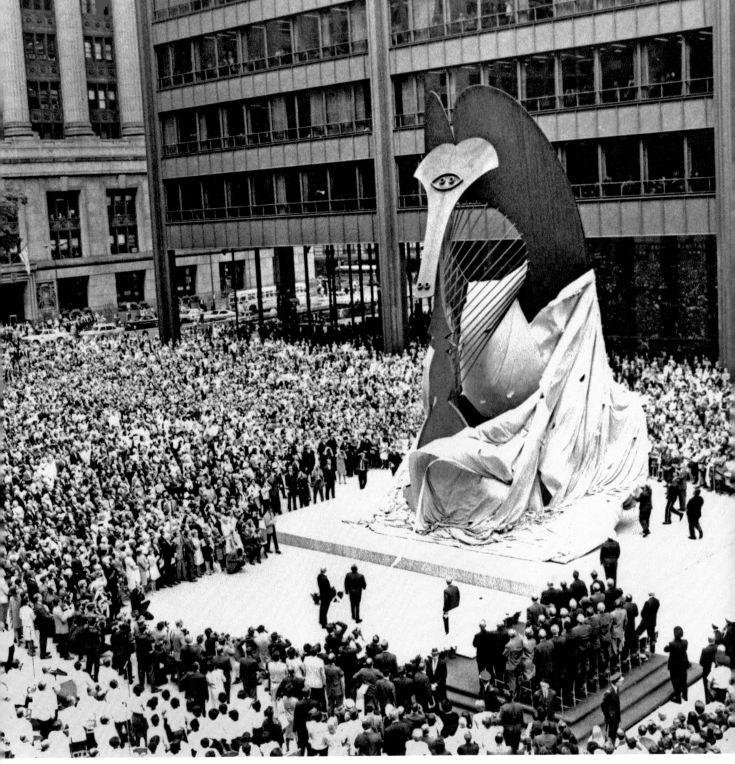

Figure 13. The unveiling of the *Richard J. Daley Center Sculpture* (1963–67) in Chicago on August 15, 1967.

1981

The Art Institute acquires *Nude with a Pitcher* (summer 1906; pl. 11), which the artist painted during a summer trip to Gosol in Catalonia with his lover, Fernande Olivier.

In February *The Morton G. Neumann Family Collection* is shown, with thirteen paintings and sculptures by Picasso. In the spring the museum presents *Master Drawings by Picasso*; numerous works from the collection are shown.

Hirschell Chipp, professor of art history from University of California, Berkeley, lectures at the Art Institute on "Picasso's Graphic Work: Art and Autobiography." A series of public programs are held in honor of the artist's 100th birthday.

1985

Great Drawings from the Art Institute of Chicago: The Harold Joachim Years, 1958–1983 includes four works by Picasso.

1986

The Arts Club presents *Portrait of an Era: Rue Winterbotham Carpenter and the Arts Club of Chicago, Seventieth Anniversary Exhibition,* with one work by Picasso.

In October *The Art of the Edge: European Frames 1300–1900* is shown at the Art Institute, with two works by Picasso from its collection.

The museum receives the gift of Picasso's *The Glass* (1911/12), formerly in the collection of fiber artist Claire Zeisler, and *Peasant Woman with a Shawl* (summer 1906; pl. 12), once in the collection of Mrs. Potter Palmer II, which greeted visitors at the entrance to Picasso's first presentation in an American gallery, at Alfred Stieglitz's Little Galleries of the Photo-Secession in March 1911.

1987

Je suis le cahier: The Sketchbooks of Picasso is presented at the Art Institute with over two hundred drawings from his private sketchbooks.

1988

The Art Institute acquires two works by the artist: the doll-like Surrealist assemblage *Figure* (1935; pl. 48) and the painting *Villa in Vallauris* (February 4, 1951; pl. 80).

1992

In May the Arts Club presents its *Seventy-Fifth Anniversary Exhibition, 1916–1991,* which includes its *Head of a Woman* by Picasso.

1993

The monumental canvas *Night Fishing at Antibes* (1939; Museum of Modern Art, New York) is on loan from August 16 through January 1, 1994.

1995

The Art Institute acquires *Weeping Woman I* (July 1, 1937; pl. 59), which is shown in May along with other major prints in the museum collection in *The Face of War: Picasso's "Weeping Woman."*

1996

In March the Smart Museum of Art presents *Drawings from the Collection of the Arts Club of Chicago,* which includes one work by the artist.

1999

Two exhibitions at the Art Institute include works by Picasso: one is featured in *Monet to Moore: The Millennium Gift of Sara Lee Corporation*; and four are presented in *Drawn to Form: Modern Drawings from Dorothy Braude Edinburg to the Harry R. and Bessie K. Braude Memorial Collection in the Art Institute of Chicago* (June 11–September 7).

2001

The Arts Club hosts a lecture by designer Paloma Picasso, daughter of the artist.

Poetics of Scale: Small-Sized Works from the Collection of Modern and Contemporary Art at the Art Institute includes one work by Picasso.

2006

In June *Drawings in Dialogue: Old Master through Modern: The Harry B. and Bessie K. Braude Memorial Collection* opens at the Art Institute with eight works by the artist.

2007

The Art Institute presents *Cézanne to Picasso: Ambroise Vollard, Patron of the Avant-Garde,* which includes over twenty-five works by the artist, two of which are from the museum's collection.

2009

In conjunction with the opening of its Modern Wing, the Art Institute presents *Modern and Contemporary Works on Paper*, with two works by the artist.

2010

The Art Institute presents *Gray Collection: Seven Centuries of Art*, an exhibition of the collection of Chicago dealer Richard Gray and his wife, Mary Lackritz Gray, with six works by Picasso (1906–62).

2011

In February the Art Institute presents *Cézanne's Harlequins*, with two works by Picasso.

2013

Chicago celebrates the centennial anniversary of the Armory Show's presentation in the city and its relationship with Pablo Picasso.

NOTES

1. The exhaustive study *Picasso and American Art* by Michael FitzGerald and Julia May Boddewyn (Whitney Museum of American Art/Yale University Press, 2006) laid the foundation for the present chronology.
2. *Breaking Home Ties* (1890; Philadelphia Museum of Art), by the American artist Thomas Hovenden (1840–1895), was voted the most popular painting at the 1893 World's Columbian Exposition in Chicago. Monroe authored many reviews on the Armory Show during its run for the *Chicago Daily Tribune*; see "Art Exhibit Opens in Chicago," *Chicago Daily Tribune*, Mar. 25, 1913.
3. Arthur Jerome Eddy, *Cubists and Post-Impressionism* (A. C. McClurg, Chicago, 1914), p. 67.
4. Daniel Catton Rich, "Chester H. Johnson: The Passing of an Influence," *Chicago Daily Tribune*, Feb. 11, 1934.
5. Joseph Winterbotham Deed of Gift to the Art Institute of Chicago, Apr. 9, 1921, Archives, the Art Institute of Chicago.
6. Prince Argotinsky to Robert Harshe (director of the Art Institute), Jan. 19, 1923, series 1, box 1, folder 21, Arts Club of Chicago Archives, Newberry Library.
7. Blanche C. Matthias, "Drawings on Display Breathe Art's New Freedom," *Chicago Herald and Examiner*, Apr. 8, 1923.
8. Clive Bell, *Catalogue of an Exhibition of Paintings by Pablo Picasso: Loaned by Paul Rosenberg of Paris and New York* (Art Institute of Chicago, 1923), n.pag.
9. Pablo Picasso, as quoted in *Modern Paintings in the Helen Birch Bartlett Memorial from the Birch Bartlett Collection* (1926; rpt. Art Institute of Chicago, 1929), p. 64.
10. Pierre Cabanne, interview with Marie-Thérèse Walter in *Présence des arts*, radio broadcast, France Culture, Apr. 13, 1974.
11. R. A. Lennon, "Modern French Art Exhibit at U. of C.," *Chicago Evening Post*, Mar. 20, 1928.
12. Agnes C. Gale," *Hyde Park Herald*, Feb. 7, 1931.
13. Eleanor Jewett, "Picasso Finds the Ugly in Two Countries" *Chicago Daily Tribune*, Jan. 5, 1932.
14. Typewritten note from James J. Sweeney to the Renaissance Society, no date [1934], Archives, Renaissance Society.
15. Eleanor Jewett, "Noted Cartoons in Tapestries Highly Praised," *Chicago Daily Tribune*, May 2, 1936.
16. Françoise Gilot and Carlton Lake, *Life with Picasso* (McGraw-Hill, 1964), p. 122.
17. "The Renaissance Exhibit," in *Townsfolk* (Apr. 1937).
18. Eleanor Jewett, "Art for Every Taste Hangs in City Galleries," *Chicago Sunday Tribune,* Oct. 15, 1939.
19. Chauncey McCormick, as quoted in "News Release from the Art Institute of Chicago," Jan. 27, 1940.
20. Daniel Catton Rich, "Foreword," in *Masterpieces of French Art Lent by the Museums and Collectors of France* (Art Institute of Chicago, 1941), n.pag.
21. Daniel Catton Rich, "Foreword," in *Twentieth Century French Paintings from the Chester Dale Collection* (Art Institute of Chicago, 1943), n.pag.
22. C. J. Bulliet, ["Abstracts at Arts Club Renew Faltering Faith"], *Chicago Daily News*, Mar. 9, 1946.
23. Picasso (1949), as quoted by Pierre Cabanne, in *Pablo Picasso: His Life and Times* (Morrow, 1977), p. 139.
24. William Hartmann to Roland Penrose, Apr. 2, 1963, Archives, Skidmore, Owings & Merrill (hereafter, SOM Archives).
25. Picasso, as quoted in "Press Release from Public Building Committee of Chicago," Sept. 20, 1966, p. 4.
26. The realization of Miró's sculpture would be postponed until 1979, when Mayor Jane Byrne agreed to find funds to move the postponed project forward. *Miró's Chicago* was unveiled in 1981 in a plaza directly across from Picasso's sculpture.
27. Paul Ware to Wilson Sporting Goods Co., Mar. 19, 1965, SOM Archives; Hartmann, as quoted in Elizabeth Chur, "How Bill Hartmann Wooed Picasso and Won the Prize," *Chicago Tribune*, Aug. 9, 1992; and William Hartmann, "Transcript of Interview with Betty J. Blum," 1989, Chicago Architects Oral History Project, Art Institute of Chicago, p. 141.
28. Hartmann to Penrose, telegram, May 25, 1965, SOM Archives.
29. Richard J. Daley to Pablo Picasso, [August] 1966, draft copy, SOM Archives.
30. Edward Barry, "Crowds See Unveiling of Picasso Work: Sculpture Hailed as New Image," *Chicago Tribune*, Aug. 16, 1967.
31. C. C. Cunningham, in *Picasso in Chicago: Paintings, Drawings, and Prints from Chicago Collections* (Art Institute of Chicago, 1968), p. 5.
32. A. James Speyer, "Picasso the Painter," in ibid., p. 8.

PICASSO AND CHICAGO: 100 WORKS

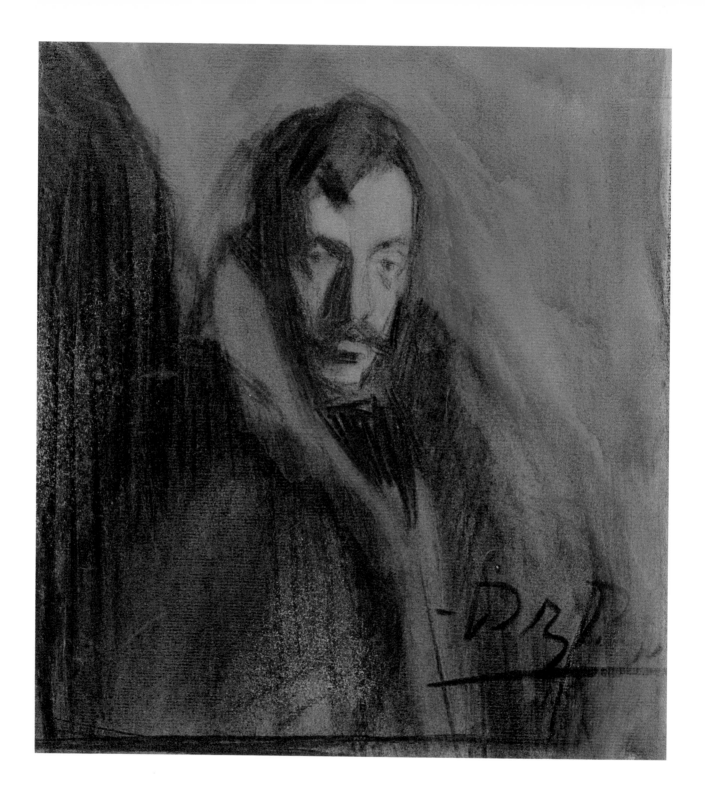

Plate 1. *Josep Cardona*, 1899 (cat. 1). Private collection.

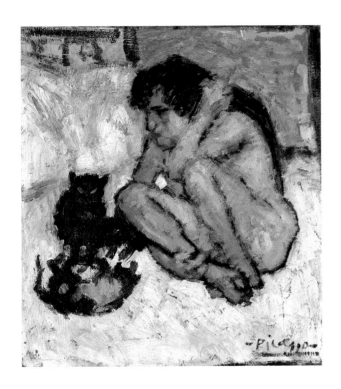

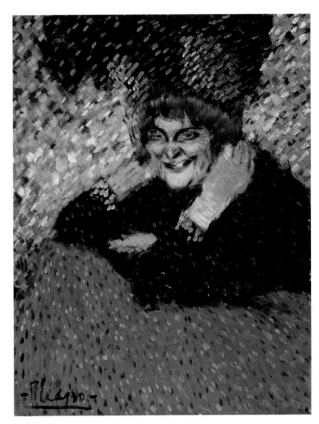

Plate 2. *Crazy Woman with Cats*, early summer 1901 (cat. 5). The Art Institute of Chicago, Amy McCormick Memorial Collection, 1942.464.
Plate 3. *Old Woman (Woman with Gloves)*, 1901 (cat. 4). Philadelphia Museum of Art, the Louise and Walter Arensberg Collection, 1950, 1950–134–158.

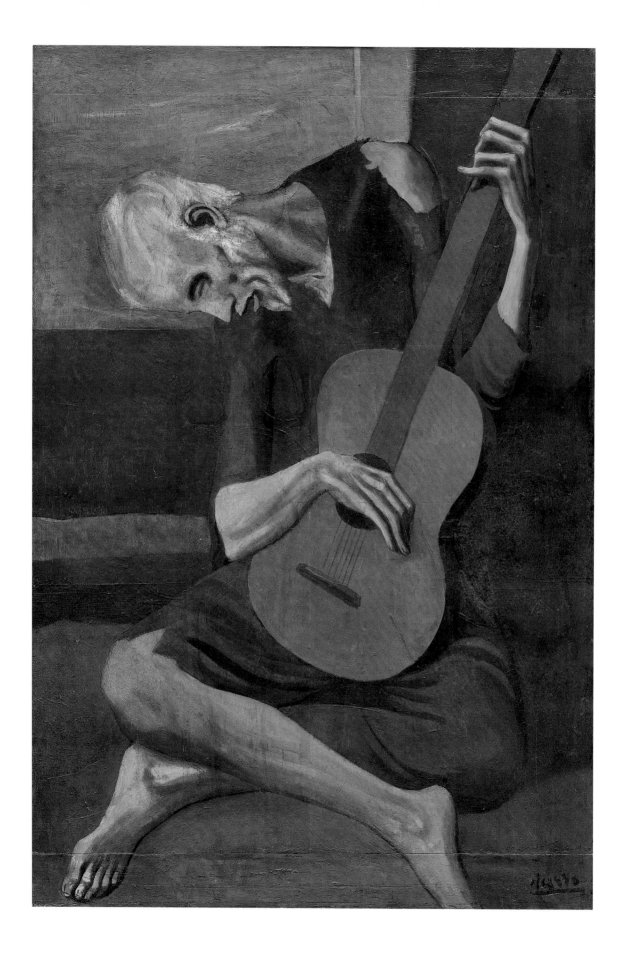

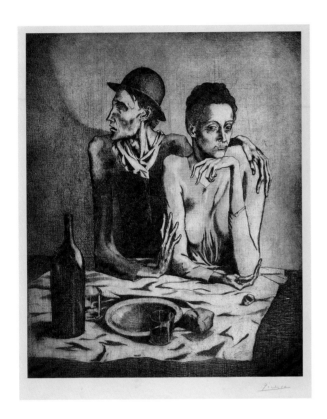
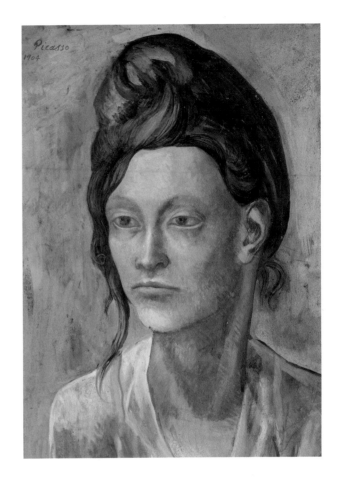

Plate 4. *The Old Guitarist*, late 1903–early 1904 (cat. 6). The Art Institute of Chicago, Helen Birch Bartlett Memorial Collection, 1926.253.

Plate 5. *The Frugal Meal*, from *The Saltimbanques*, September 1904 (cat. 10). The Art Institute of Chicago, Clarence Buckingham Collection, 1963.825.

Plate 6. *Woman with a Helmet of Hair*, 1904 (cat. 7). The Art Institute of Chicago, bequest of Kate L. Brewster, 1950.128.

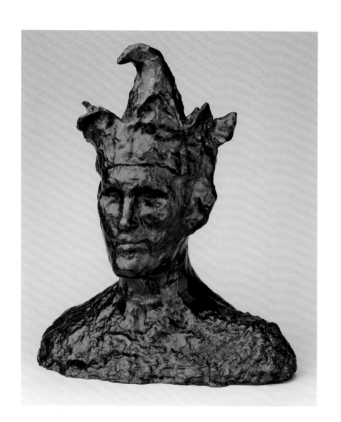

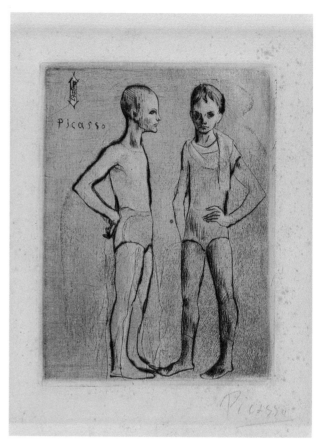

Plate 7. *Jester*, spring 1905 (cat. 20). The Art Institute of Chicago, Kate L. Brewster Collection, 1964.193.

Plate 8. *The Two Saltimbanques*, from *The Saltimbanques*, 1905 (cat. 15). The Art Institute of Chicago, collection of Francey and Dr. Martin L. Gecht, 53.2008.

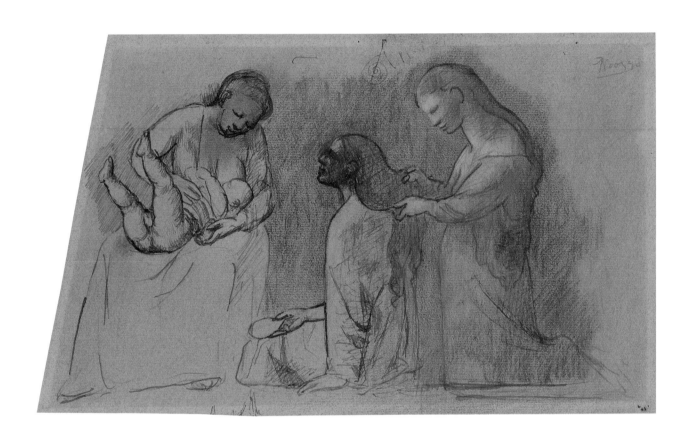

Plate 9. *Study for "La Coiffure,"* 1906 (cat. 22). The Art Institute of Chicago, Ada Turnbull Hertle Fund, 1968.463.

Plate 10. *Peasant Girls from Andorra*, late summer 1906 (cat. 27). The Art Institute of Chicago, gift of Robert Allerton, 1930.933.

Plate 11. *Nude with a Pitcher*, summer 1906 (cat. 26). The Art Institute of Chicago, gift of Mary and Leigh Block, 1981.14.

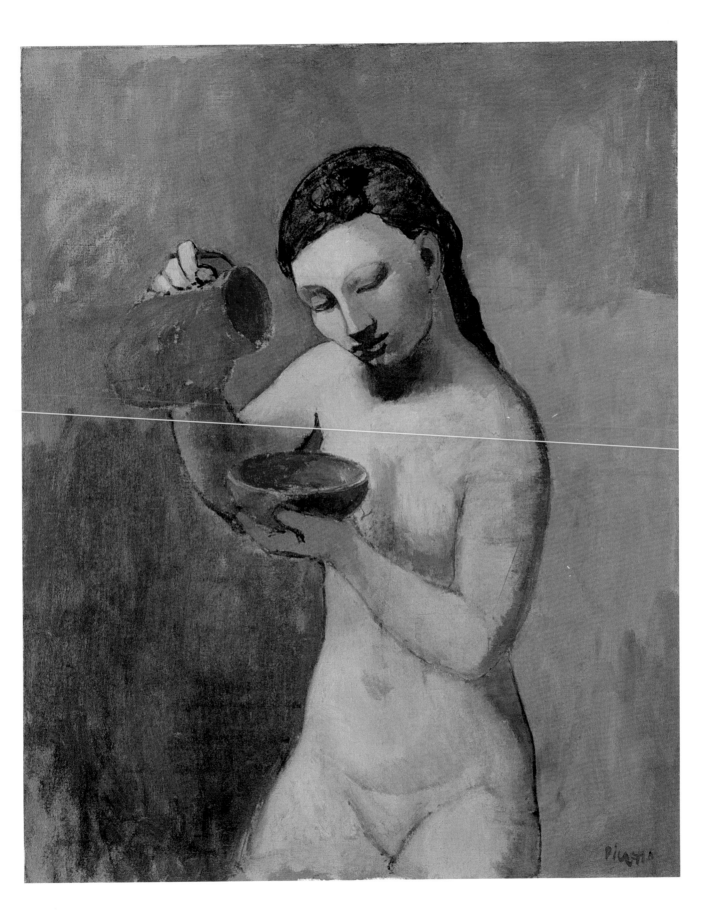

Plate 12. *Peasant Woman with a Shawl*, summer 1906 (cat. 24). The Art Institute of Chicago, through prior bequest of Mrs. Gordon Palmer, 1986.1595.

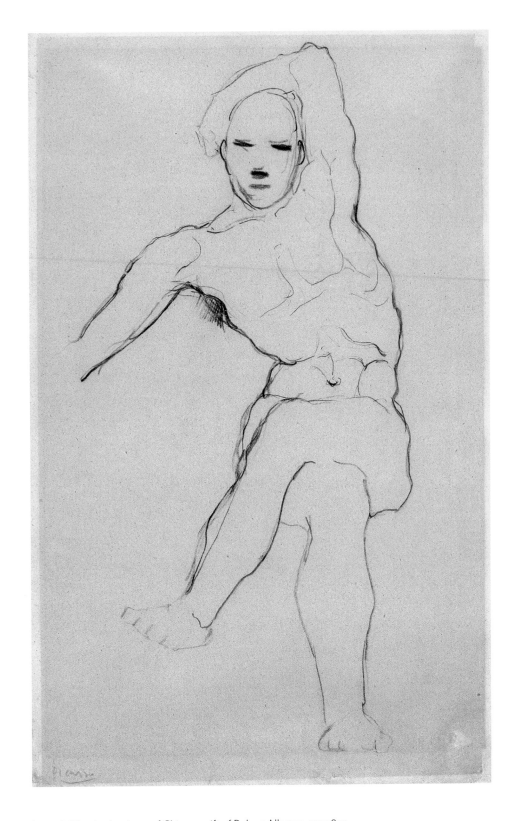

Plate 13. *Study of a Seated Man*, 1905 (cat. 17). The Art Institute of Chicago, gift of Robert Allerton, 1924.803.

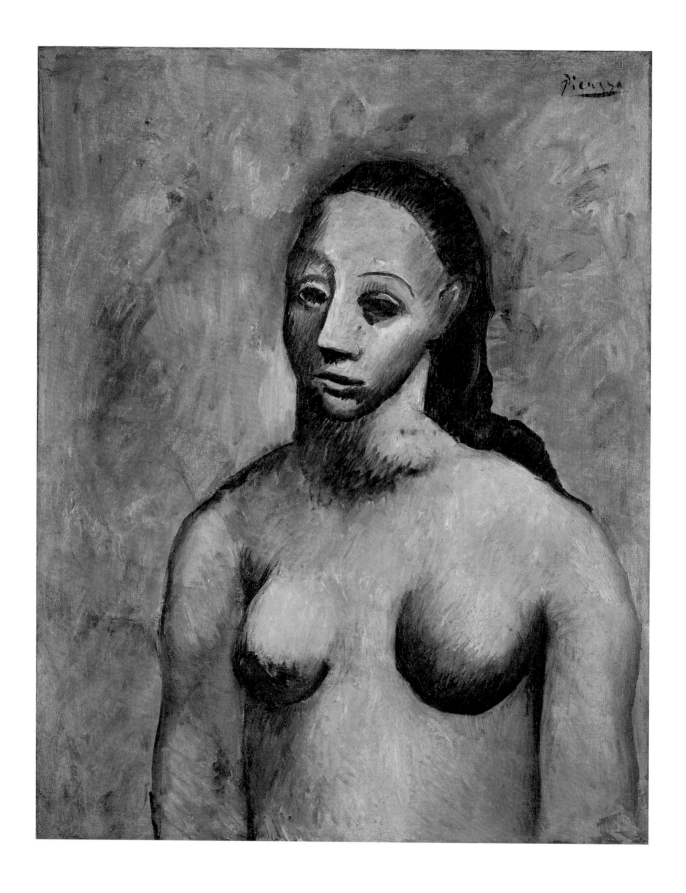

Plate 14. *Half-Length Female Nude,* fall 1906 (cat. 29). The Art Institute of Chicago, gift of Florene May Schoenborn and Samuel A. Marx, 1959.619.

Plate 15. *Female Nude,* 1906 (cat. 21). Richard and Mary L. Gray and the Gray Collection Trust.
Plate 16. *Two Nudes, Standing,* fall 1906 (cat. 28). The Art Institute of Chicago, gift of Mrs. Potter Palmer, 1944.575.

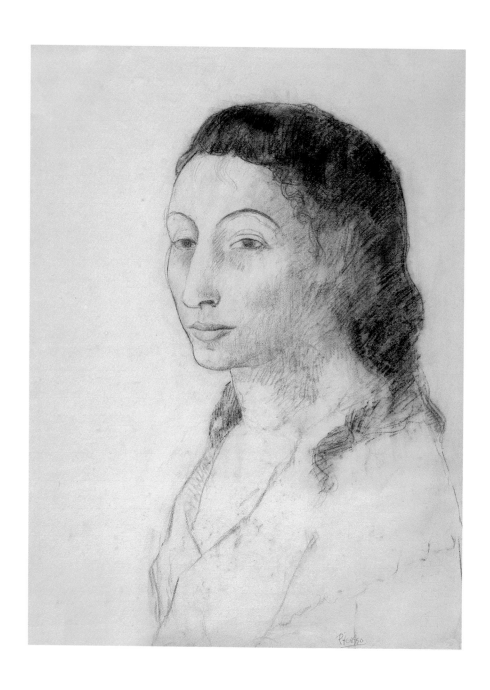

Plate 17. *Fernande Olivier*, summer 1906 (cat. 25). The Art Institute of Chicago, gift of Hermann Waldeck, 1951.210.

Plate 18. *Head of a Woman with Chignon (Fernande)*, summer 1906 (cat. 23). Collection of Susan and Lew Manilow.

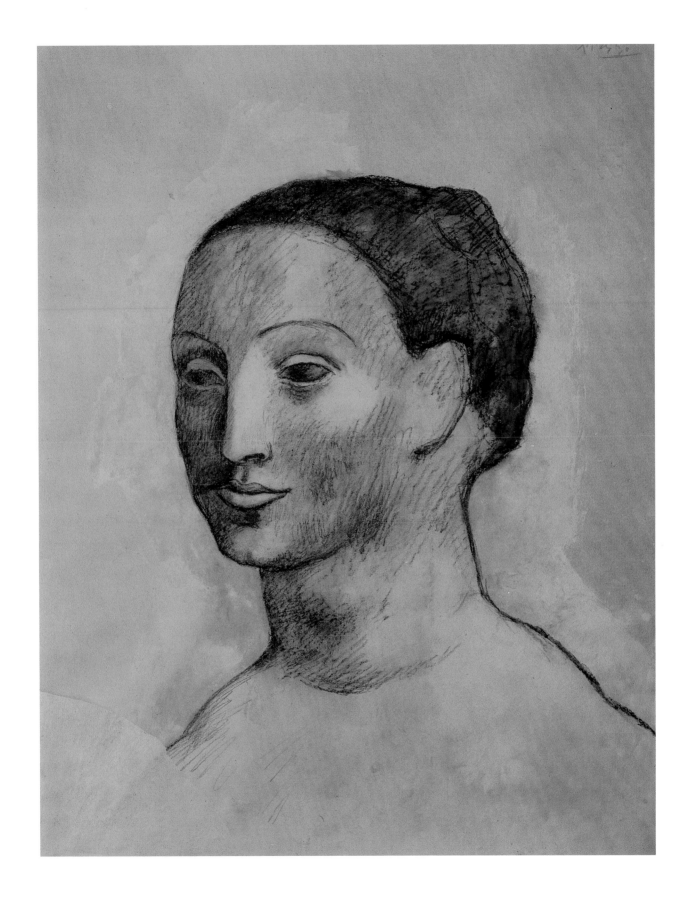

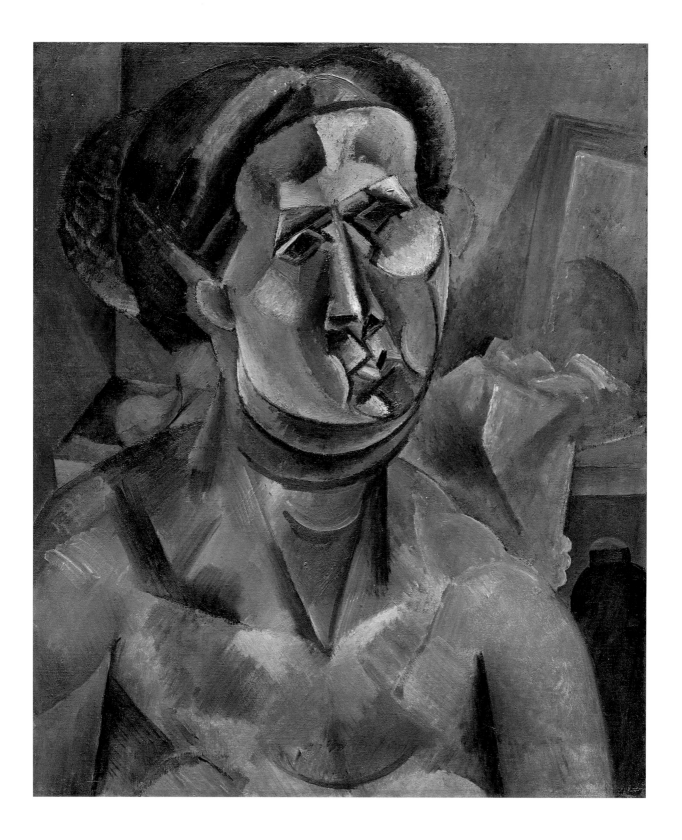

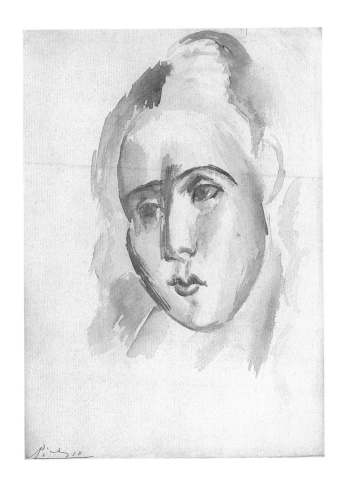

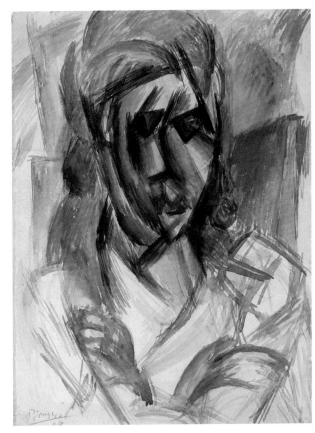

Plate 19. *Head of a Woman*, summer 1909 (cat. 40). The Art Institute of Chicago, Joseph Winterbotham Collection, 1940.5.

Plate 20. *Head of a Woman (Fernande)*, winter 1909–10 (cat. 45). Private collection.
Plate 21. *Bust of a Woman*, late 1909 (cat. 44). The Art Institute of Chicago, gift of Mr. and Mrs. Roy J. Friedman, 1964.215.

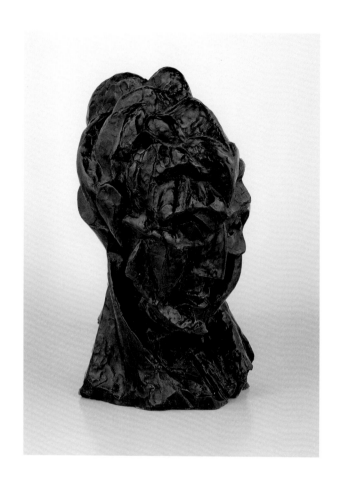

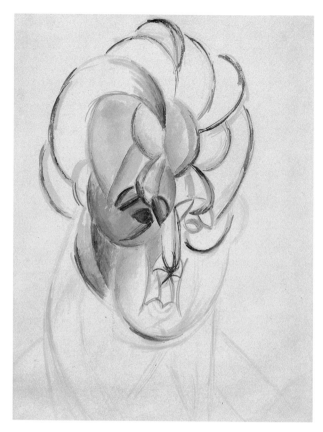

Plate 22. *Head of a Woman (Fernande),* fall 1909 (cast 1910) (cat. 41). The Art Institute of Chicago, Alfred Stieglitz Collection, 1949.584.
Plate 23. *Head of a Woman,* fall 1909 (cat. 42). The Art Institute of Chicago, Alfred Stieglitz Collection, 1949.578.

Plate 24. *Head of a Woman,* 1909 (cat. 38). The Art Institute of Chicago, Edward E. Ayer Endowment Fund in memory of
Charles L. Hutchinson, 1945.136.

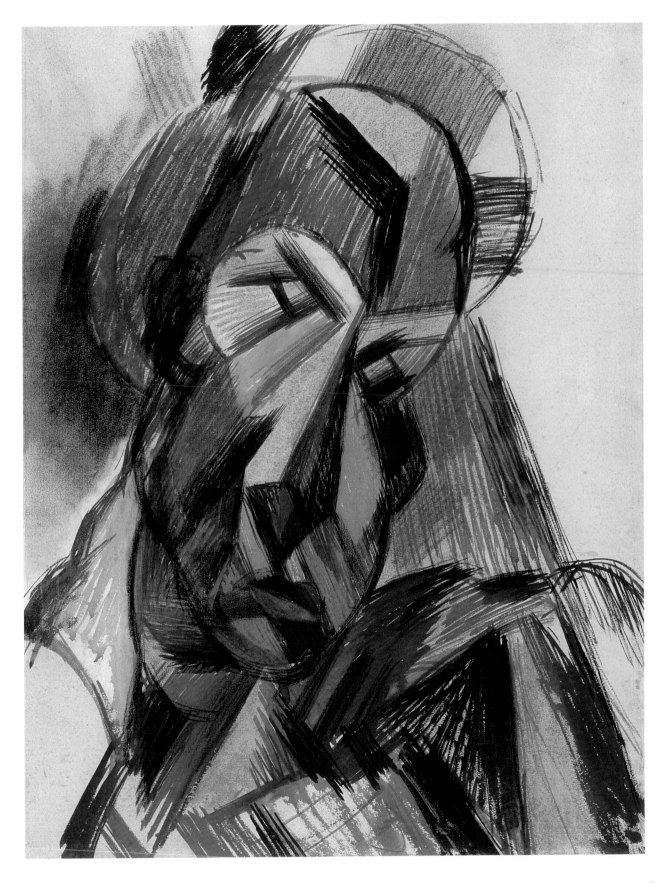

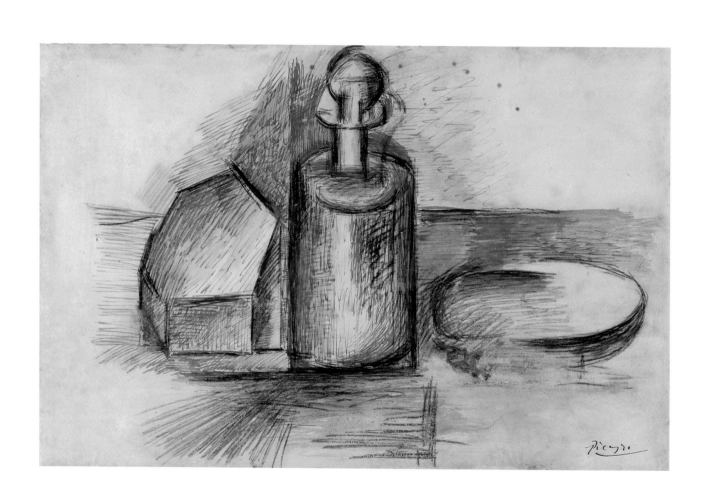

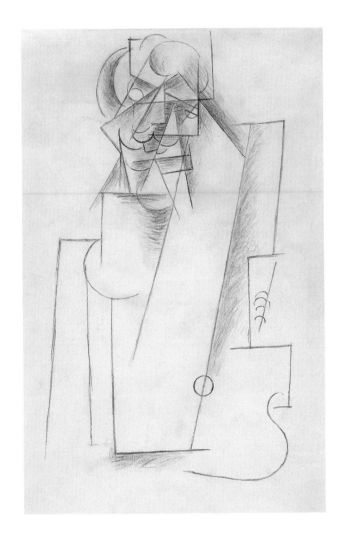

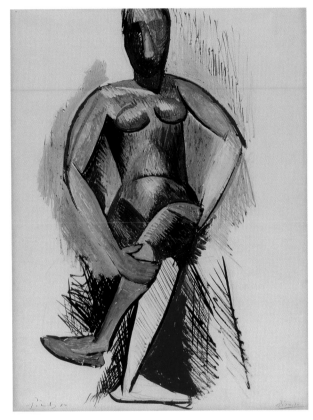

Plate 25. *Still Life with Bottle*, fall 1909 (cat. 43). The Art Institute of Chicago, gift of William M. Eisendrath, Jr., 1940.1047R.

Plate 26. *Mustachioed Man with a Guitar*, 1912 (cat. 51). The Art Institute of Chicago, collection of Francey and Dr. Martin L. Gecht, 55.2008.

Plate 27. *Seated Female Nude*, summer 1909 (cat. 39). The Art Institute of Chicago, gift of Florene May Schoenborn and Samuel A. Marx, 1953.192.

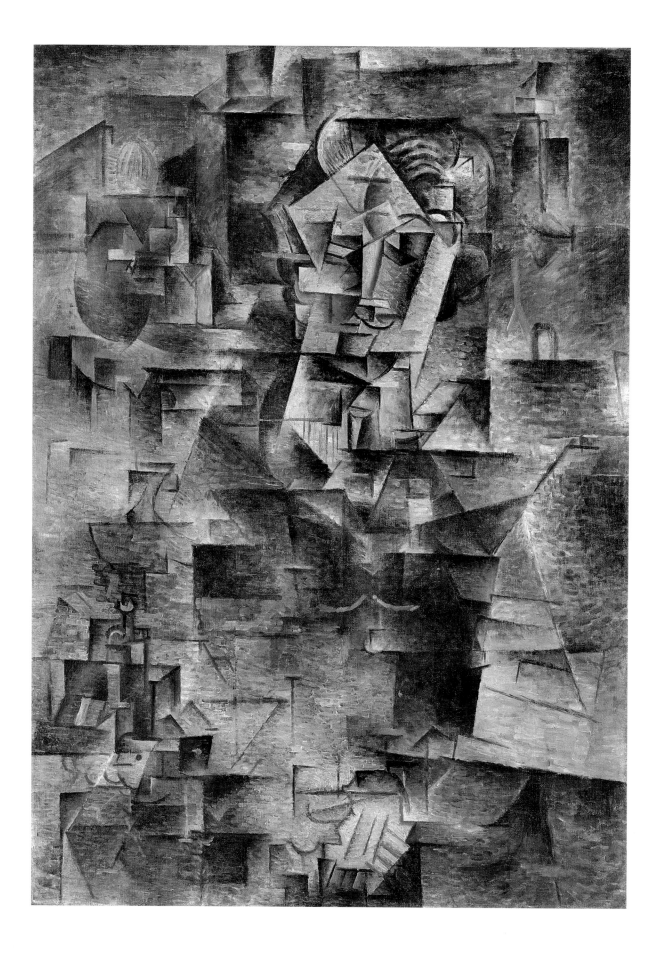

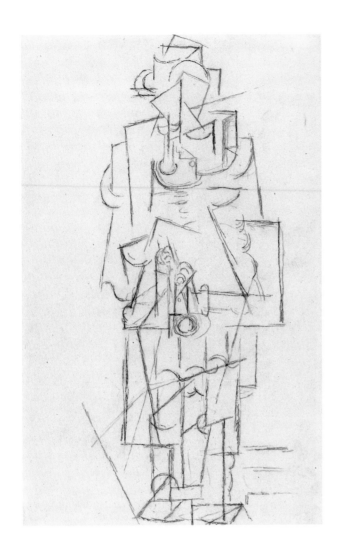

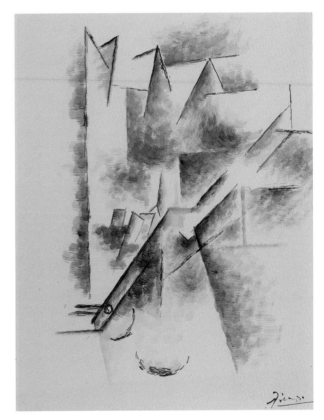

Plate 28. *Daniel-Henry Kahnweiler*, fall 1910 (cat. 46). The Art Institute of Chicago, gift of Mrs. Gilbert W. Chapman in memory of Charles B. Goodspeed, 1948.561.

Plate 29. *Man with Clarinet*, summer 1911 (cat. 49). Richard and Mary L. Gray and the Gray Collection Trust.

Plate 30. *Fan*, summer 1911 (cat. 48). Ursula and R. Stanley Johnson Family Collection.

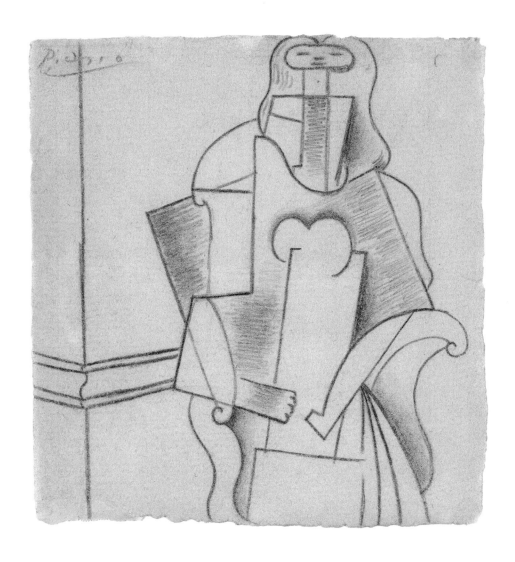

Plate 31. *Seated Woman in an Armchair*, 1915 (cat. 54). The Art Institute of Chicago, Dorothy Braude Edinburg Art LLC, 409.2010.

Plate 32. *Man with a Pipe (Man with a Mustache, Buttoned Vest, and Pipe)*, 1915 (cat. 53). The Art Institute of Chicago, gift of Mrs. Leigh B. Block in memory of Albert D. Lasker, 1952.1116.

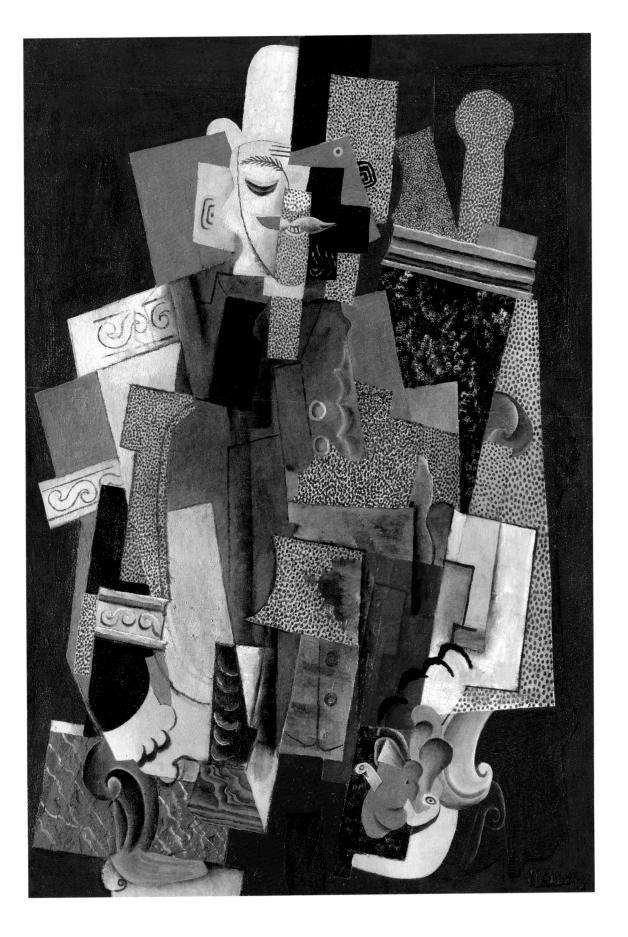

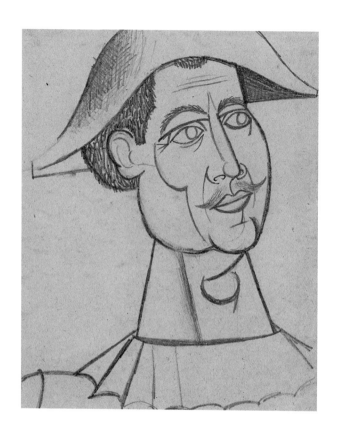

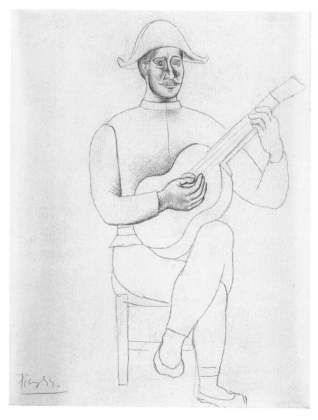

Plate 33. *Head of Harlequin*, 1916 (cat. 56). The Art Institute of Chicago, Dorothy Braude Edinburg Art LLC, 408.2010.

Plate 34. *Harlequin Playing the Guitar*, c. 1916 (cat. 57). Collection of Richard and Gail Elden.

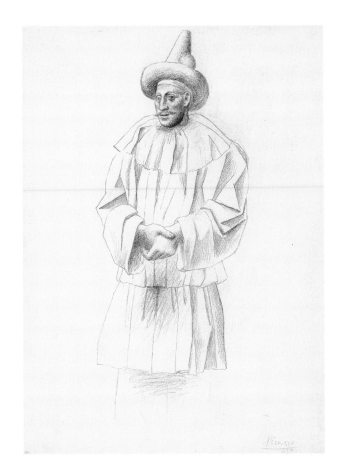

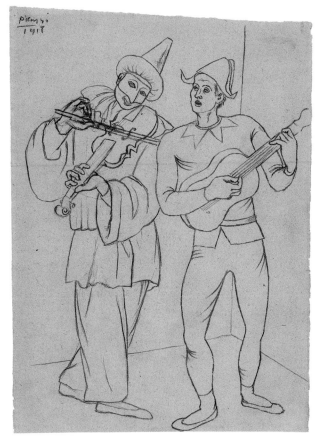

Plate 35. *Pierrot*, 1918 (cat. 61). The Art Institute of Chicago, gift of Dorothy Braude Edinburg to the Harry B. and Bessie K. Braude Memorial Collection, 1998.718.

Plate 36. *Pierrot and Harlequin*, 1918 (cat. 60). The Art Institute of Chicago, given in memory of Charles Barnett Goodspeed by Mrs. Charles B. Goodspeed, 1947.875.

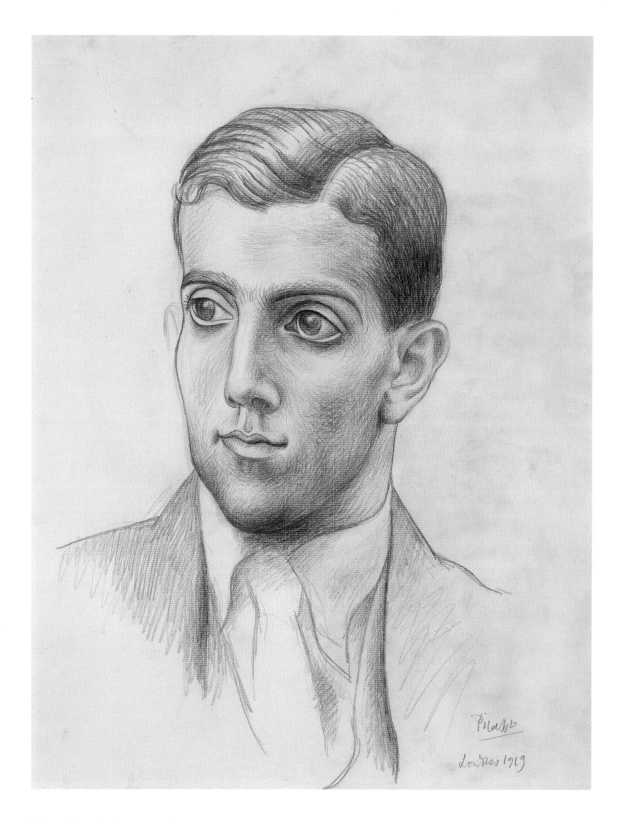

Plate 37. *Léonide Massine*, 1919 (cat. 63). The Art Institute of Chicago, Margaret Day Blake Collection, 1972.970.

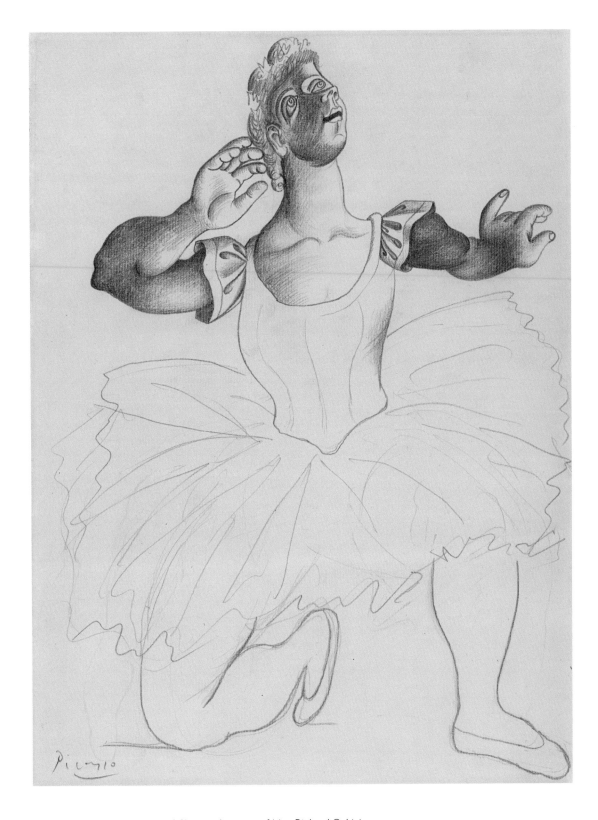

Plate 38. *Dancer*, 1919 (cat. 64). The Art Institute of Chicago, bequest of Mrs. Richard Q. Livingston, 1993.291.

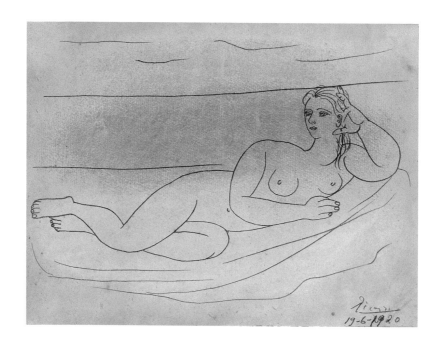

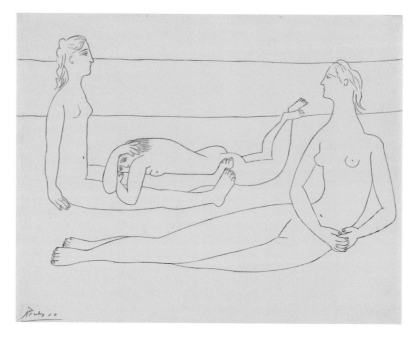

Plate 39. *Nude Reclining on the Beach*, June 19, 1920 (cat. 65). Collection of Richard and Gail Elden.

Plate 40. *Three Nudes Reclining on a Beach*, June 22, 1920 (cat. 66). The Art Institute of Chicago, gift of Dorothy Braude Edinburg to the Harry B. and Bessie K. Braude Memorial Collection, 1998.719.

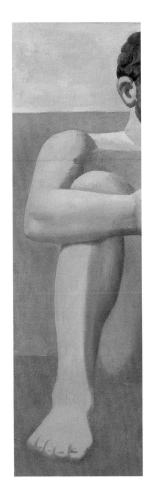
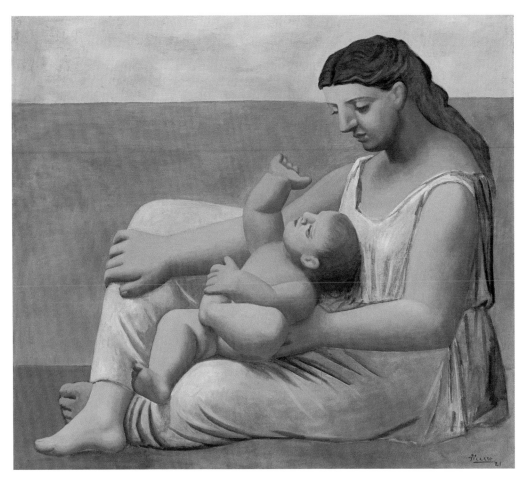

Plate 41a. *Fragment of "Mother and Child,"* 1921 (cat. 70). The Art Institute of Chicago, gift of Pablo Picasso, 1968.100.
Plate 41. *Mother and Child*, 1921 (cat. 69). The Art Institute of Chicago, restricted gift of Maymar Corporation, Mrs. Maurice L. Rothschild, and Mr. and Mrs. Chauncey McCormick; Mary and Leigh Block Fund; Ada Turnbull Hertle Endowment; through prior gift of Mr. and Mrs. Edwin E. Hokin, 1954.270.

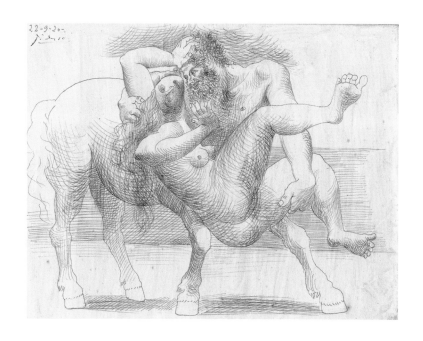

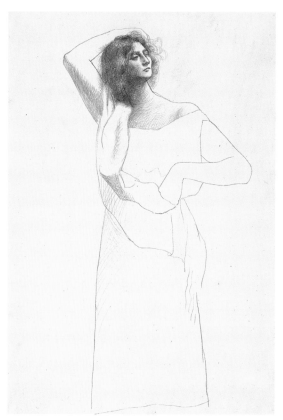

Plate 42. *Nessus and Deianira*, September 22, 1920 (cat. 68). The Art Institute of Chicago, Clarence Buckingham Collection, 1965.783.

Plate 43. *Woman Standing with One Arm behind Her Head*, 1922 (cat. 74). The Art Institute of Chicago, collection of Francey and Dr. Martin L. Gecht, 56.2008.

Plate 44. *Head of a Woman*, 1922 (cat. 73). The Arts Club of Chicago, Arts Club Purchase Fund, 1926.

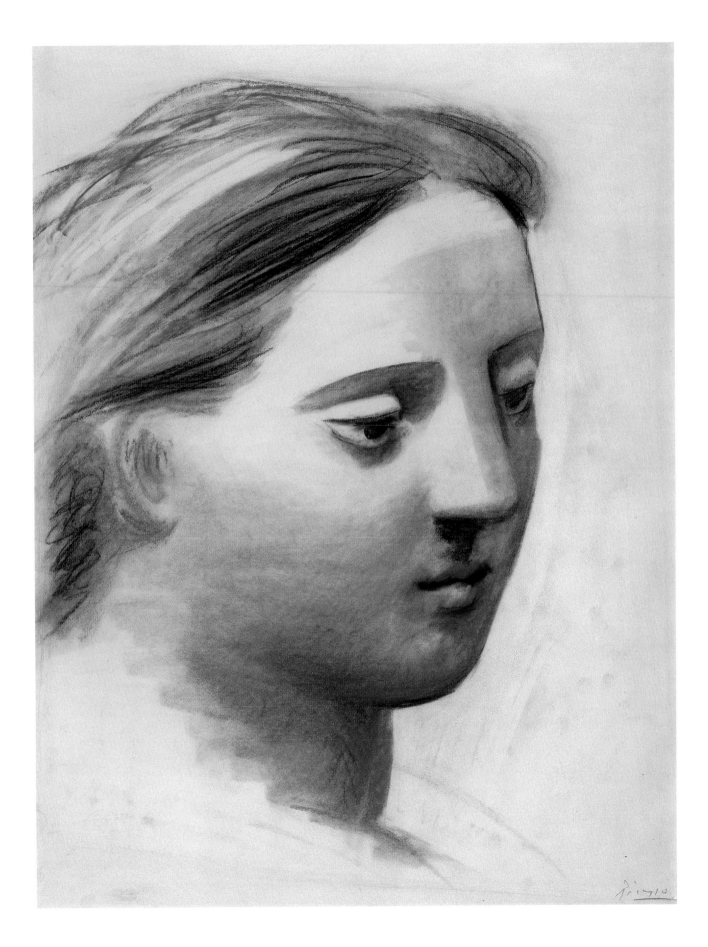

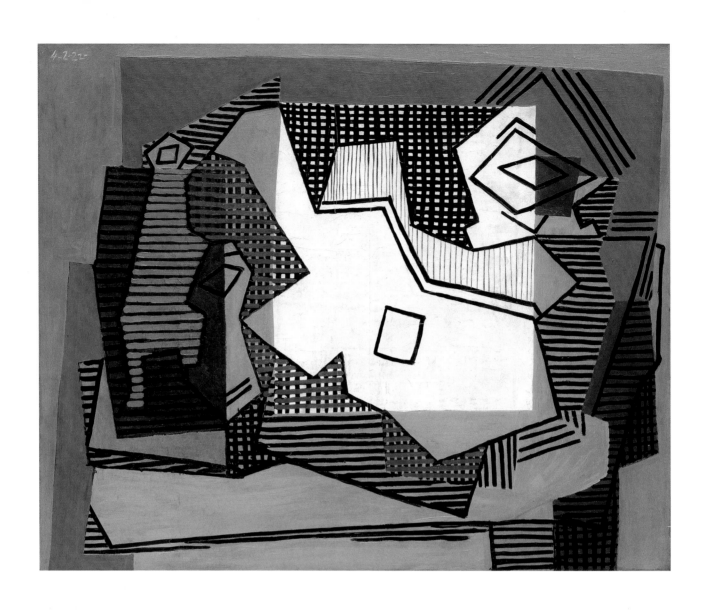

Plate 45. *Still Life*, February 4, 1922 (cat. 75). The Art Institute of Chicago, Ada Turnbull Hertle Endowment, 1953.28.

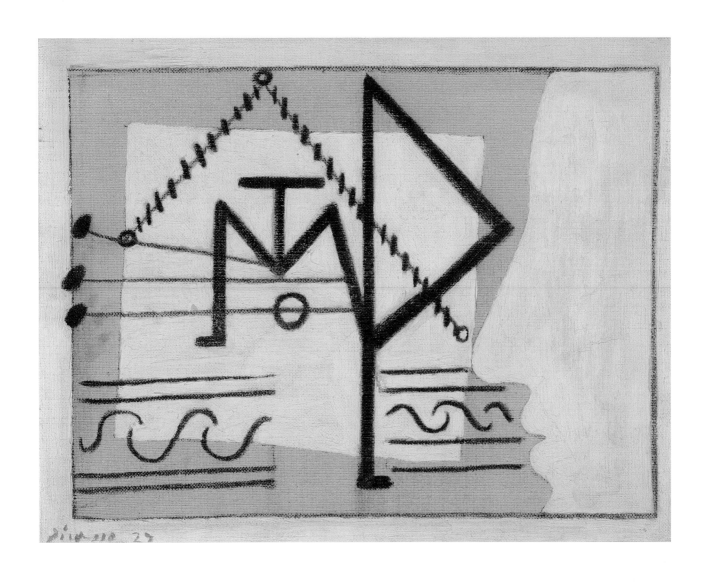

Plate 46. *Head (Hanging Guitar with Profile)*, 1927 (see p. 112). Private collection.

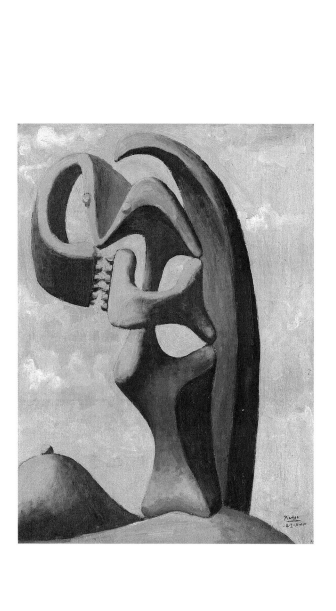

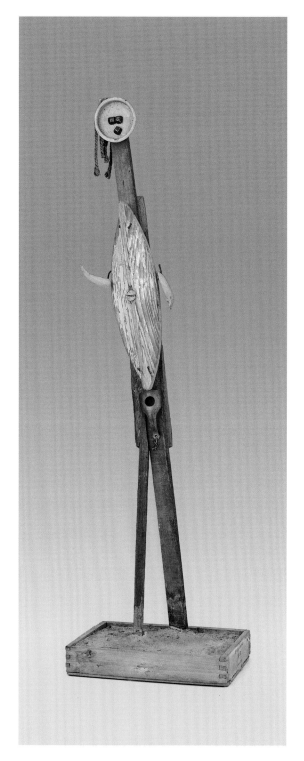

Plate 47. *Abstraction: Background with Blue Cloudy Sky*, January 4, 1930 (cat. 93). The Art Institute of Chicago, gift of Florene May Schoenborn and Samuel A. Marx; Wilson L. Mead Fund, 1955.748.

Plate 48. *Figure*, 1935 (cat. 141). The Art Institute of Chicago, Mary L. and Leigh B. Block, and Alyce and Edwin DeCosta and the Walter E. Heller Foundation endowments; through prior gifts of Mary L. and Leigh B. Block, 1988.428.

Plate 49. *Head*, 1927 (cat. 79). The Art Institute of Chicago, gift of Florene May Schoenborn and Samuel A. Marx, 1951.185.

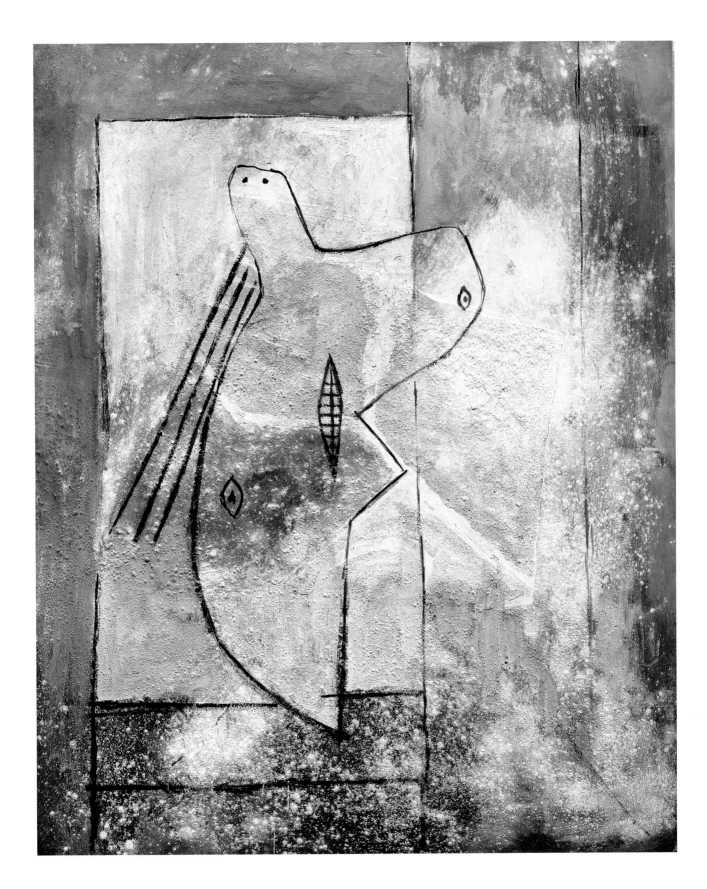

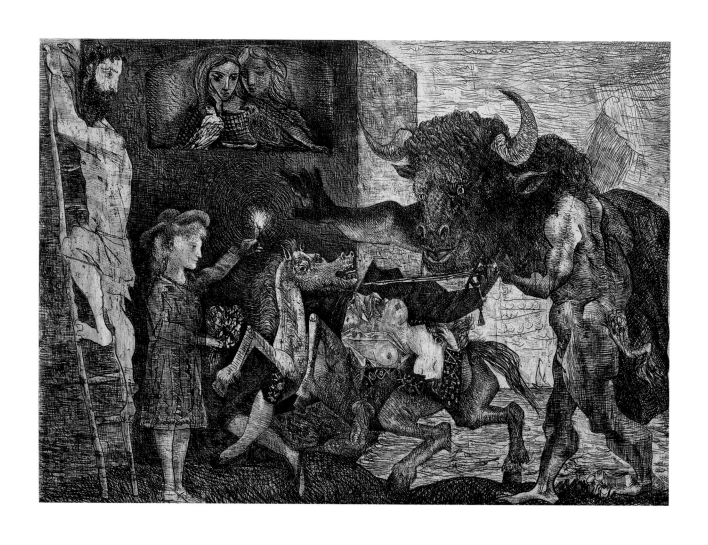

Plate 50. *Minotauromachia*, March 23–May 3, 1935 (cat. 142). The Art Institute of Chicago, gift of Mrs. Helen Pauling Donnelley, 1947.160.

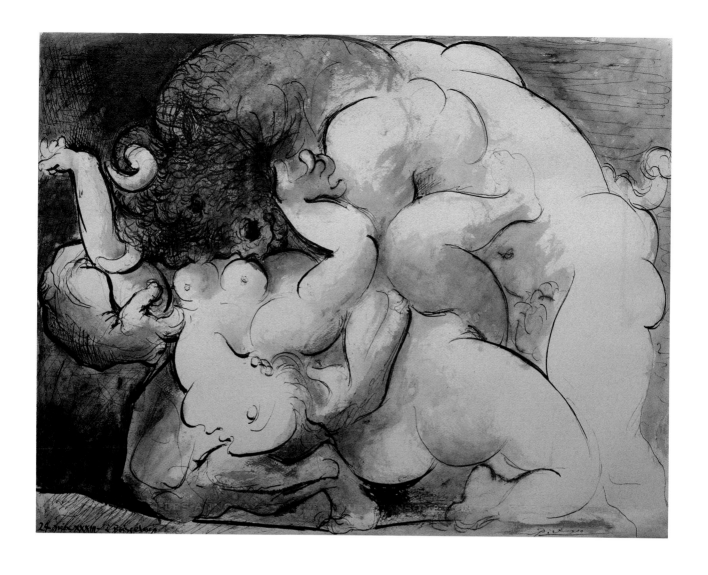

Plate 51. *The Minotaur*, June 24, 1933 (cat. 127). The Art Institute of Chicago, Margaret Day Blake Collection, 1967.516.

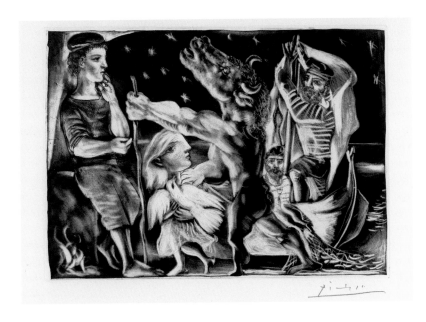

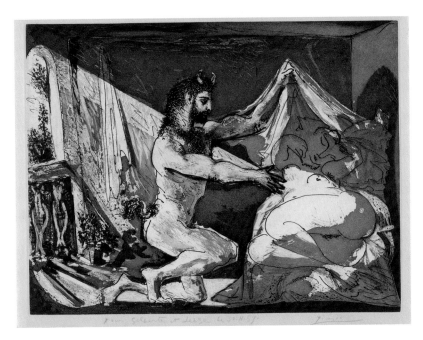

Plate 52. *Blind Minotaur Led by a Young Girl*, from *Vollard Suite*, 1934 (cat. 131). Collection of Nancy and Steve Crown.

Plate 53. *Faun Uncovering a Woman (Jupiter and Antiope, after Rembrandt)*, from *Vollard Suite*, June 12, 1936 (cat. 158). The Art Institute of Chicago, gift of Lesley Ryan Brown and her husband Alan J. Brown in commemoration of her citizenship, May 21, 1986, 1986.855.

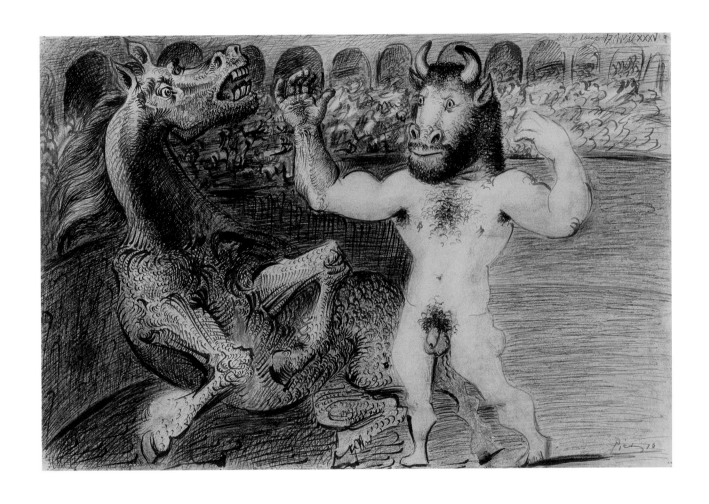

Plate 54. *Minotaur and Wounded Horse*, April 17, 1935 (cat. 143). The Art Institute of Chicago, anonymous gift, 1991.673.

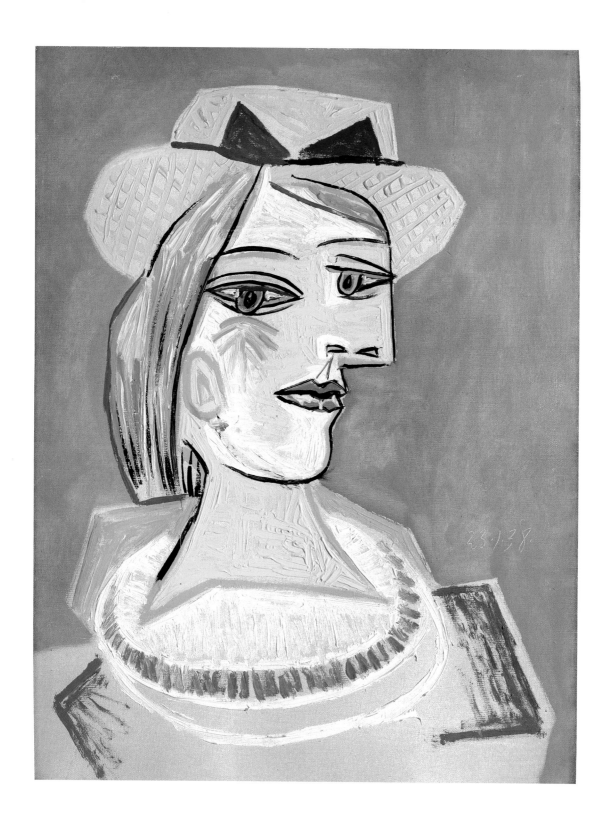

Plate 55. *Head of a Woman with Straw Hat on a Pink Background*, January 23, 1938 (cat. 167). Private collection.

Plate 56. *The Red Armchair*, December 16, 1931 (cat. 114). The Art Institute of Chicago, gift of Mr. and Mrs. Daniel Saidenberg, 1957.72.

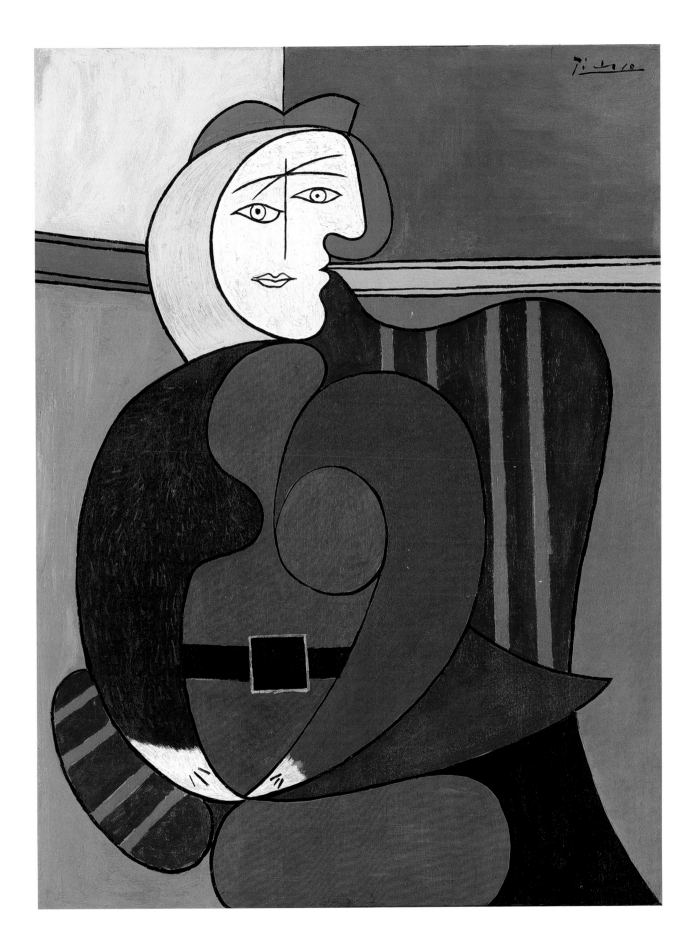

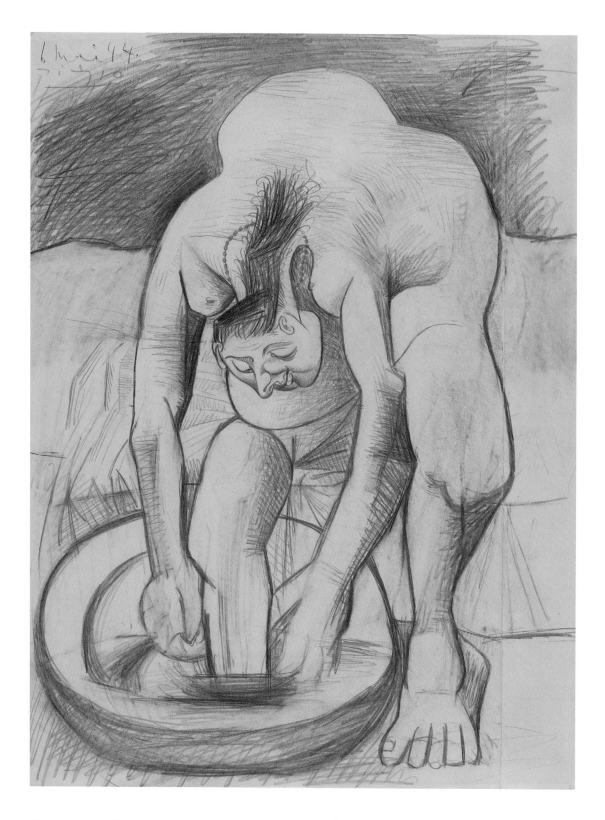

Plate 57. *Woman Washing Her Feet*, May 6, 1944 (cat. 173). The Art Institute of Chicago, gift from the estate of Curt Valentin, 1955.603.

Plate 58. *Head of a Woman (Dora Maar)*, April 1, 1939 (cat. 169). Private collection.

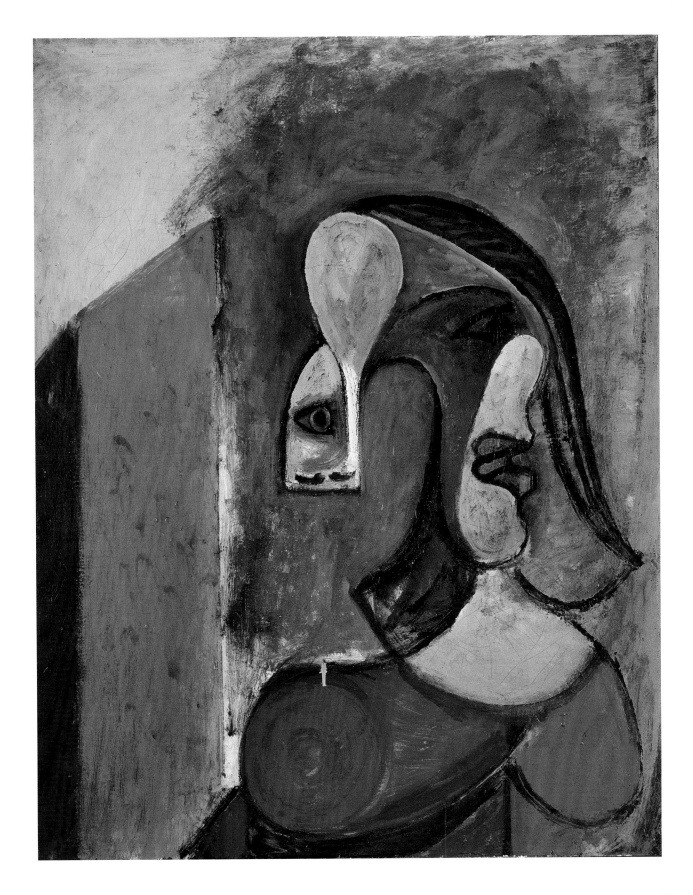

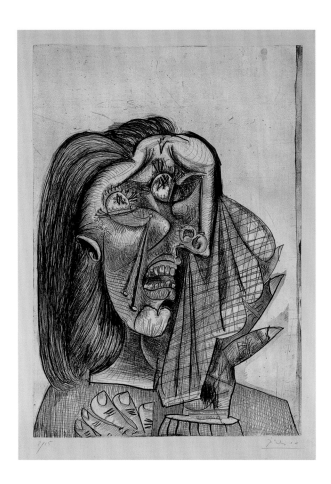
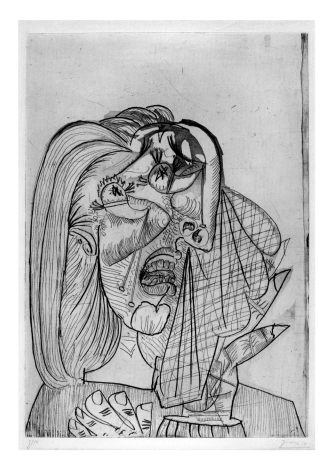

Plate 59. *Weeping Woman I*, July 1, 1937 (cat. 163). The Art Institute of Chicago, through prior acquisition of the Martin A. Ryerson Collection with the assistance of the Noel and Florence Rothman Family and the Margaret Fisher Endowment, 1994.707.
Plate 60. *Weeping Woman I*, July 1, 1937 (cat. 164). Gecht Family Art Collection.

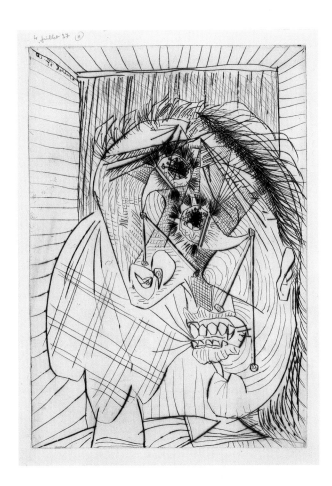
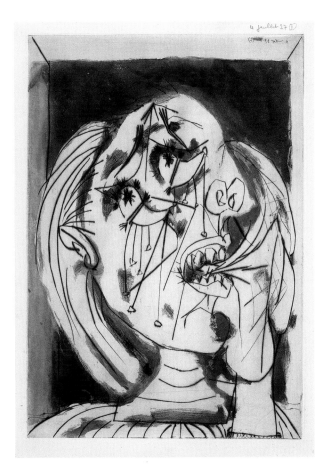

Plate 61. *Weeping Woman III*, July 4, 1937 (cat. 165). Private collection.
Plate 62. *Weeping Woman IV*, July 4, 1937 (cat. 166). Private collection.

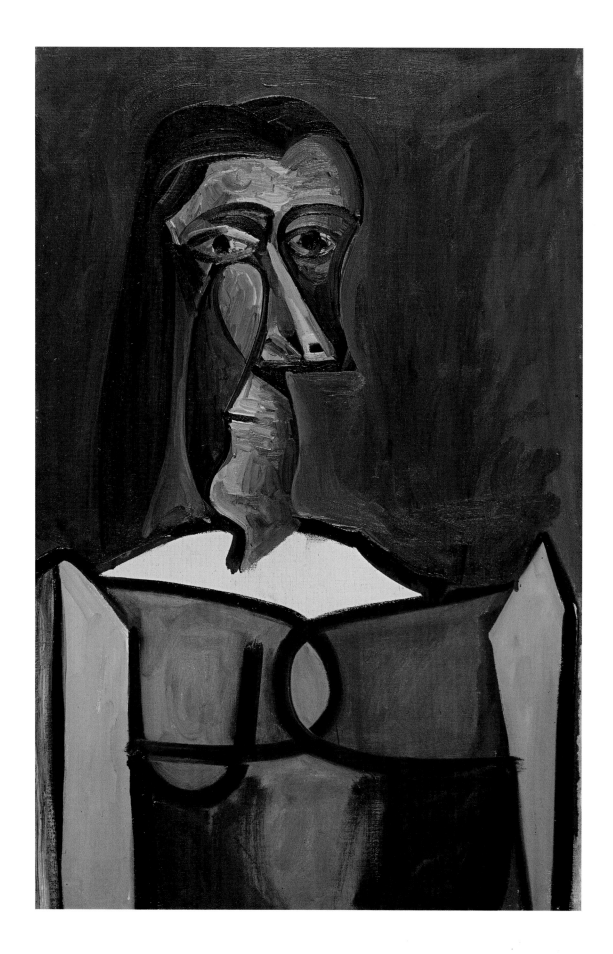

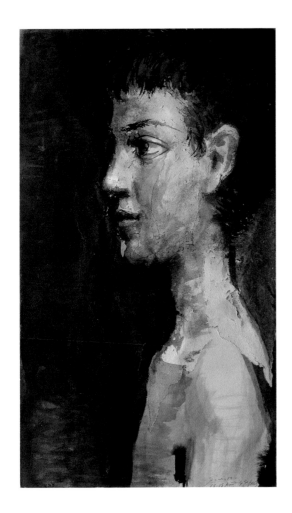

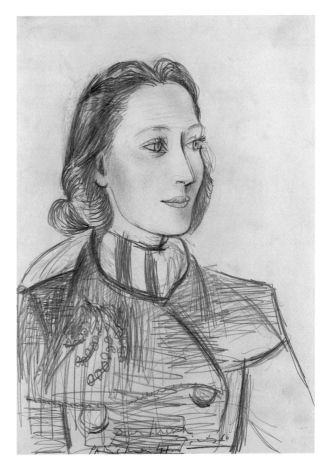

Plate 63. *Bust of a Woman*, October 12, 1943 (cat. 172). Collection of Sylvia Neil and Daniel Fischel.

Plate 64. *Head of a Young Boy*, August 13–15, 1944 (cat. 174). The Art Institute of Chicago, bequest of Florene May Schoenborn, 2012.569.

Plate 65. *Portrait of Nusch Éluard*, May 1941 (cat. 170). The Art Institute of Chicago, Dorothy Braude Edinburg Art LLC, 404.2010.

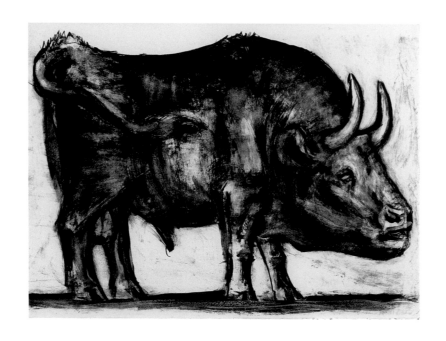

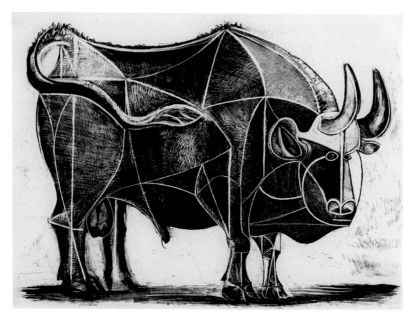

Plate 66. *Bull II*, December 12, 1945 (cat. 176). Private collection.
Plate 67. *Bull IV*, December 22, 1945 (cat. 178). Private collection.

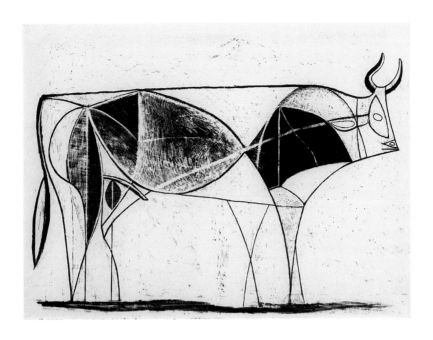

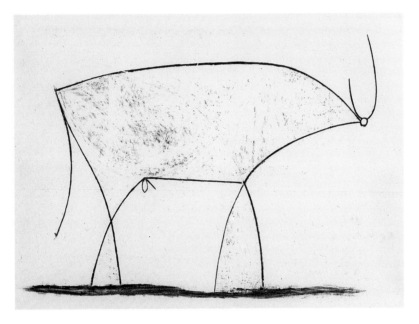

Plate 68. *Bull VIII*, January 2, 1946 (cat. 182). Private collection.
Plate 69. *Bull XI*, January 17, 1946 (cat. 185). Private collection.

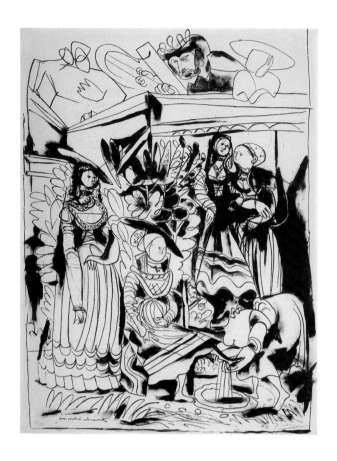

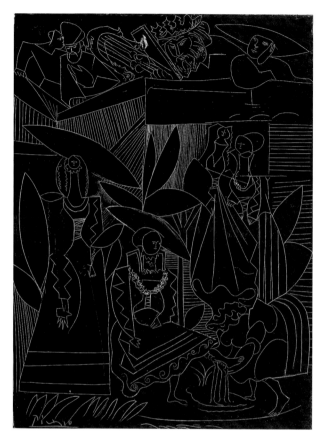

Plate 70. *David and Bathsheba*, March 30, 1947 (cat. 187). The Art Institute of Chicago, restricted gift of Peter B. Bensinger, 1968.473.
Plate 71. *David and Bathsheba*, March 30, 1947 (cat. 188). The Art Institute of Chicago, Prints and Drawings Purchase Account and Mrs. Albert Roullier and Miss Roullier Fund, 1968.474.

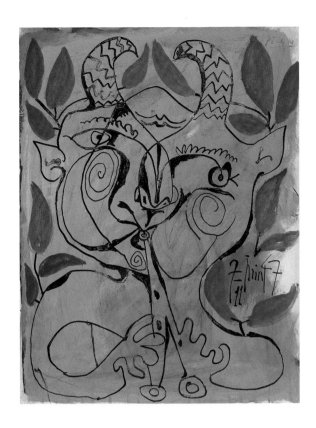

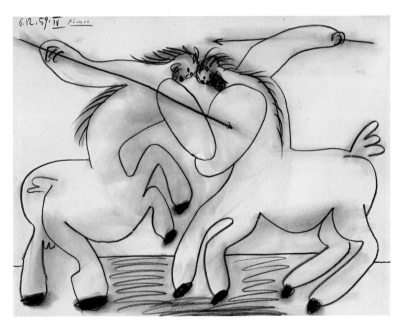

Plate 72. *The Faun Musician*, June 7–11, 1947 (cat. 189). The Art Institute of Chicago, gift of Dorothy Braude Edinburg
to the Harry B. and Bessie K. Braude Memorial Collection, 1998.720.
Plate 73. *Combat of Centaurs*, December 6, 1959 (cat. 213). The Art Institute of Chicago, Dorothy Braude Edinburg Art LLC, 406.2010.

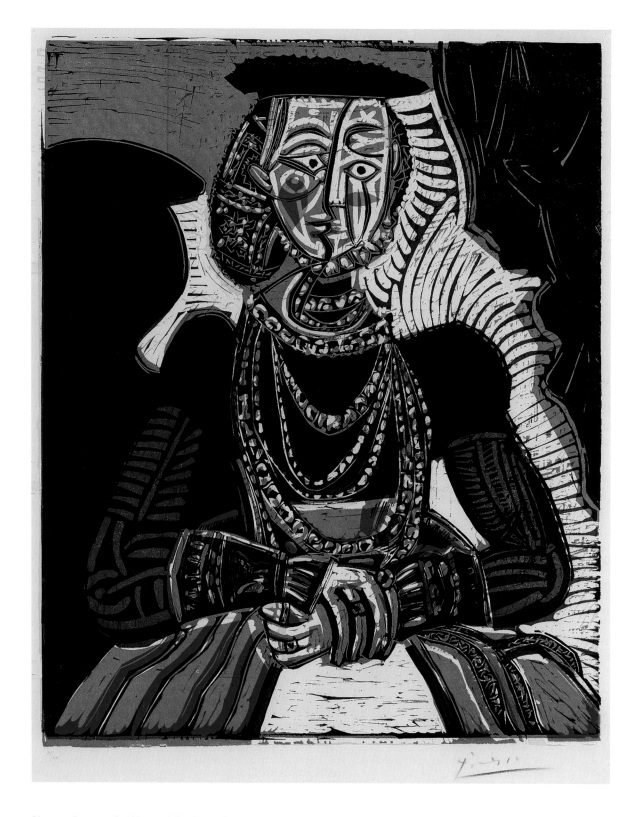

Plate 74. *Portrait of a Woman (after Lucas Cranach the Younger)*, July 4, 1958 (cat. 209). Private collection.

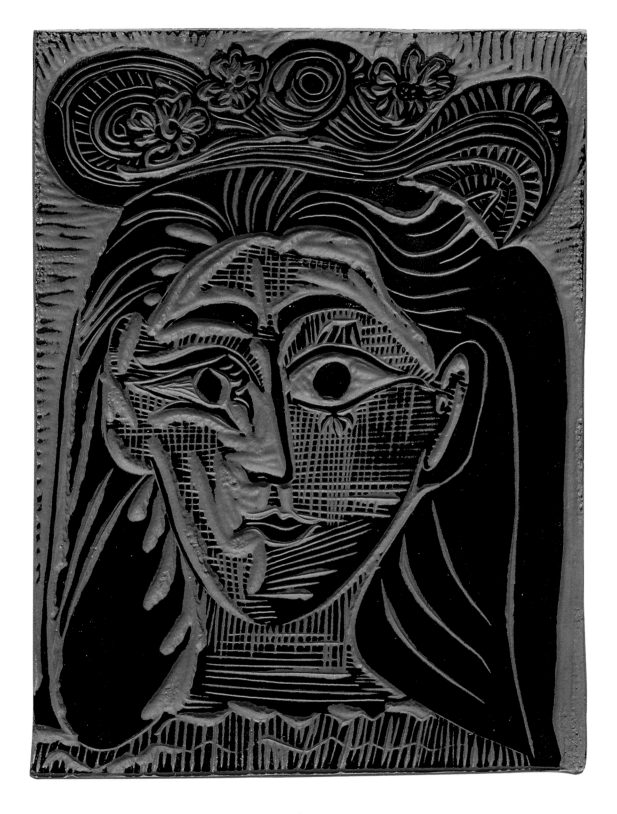

Plate 75. *Woman's Head with a Crown of Flowers*, 1964 (cat. 232). Private collection.

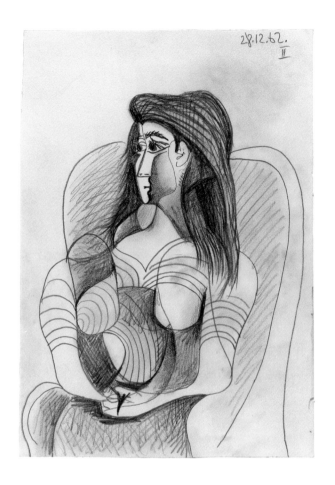

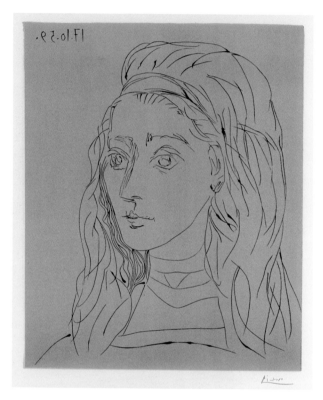

Plate 76. *Portrait of Jacqueline*, December 28, 1962 (cat. 230). Richard and Mary L. Gray and the Gray Collection Trust.
Plate 77. *Jacqueline*, October 17, 1959 (cat. 212). Collection of Nancy and Steve Crown.

Plate 78. *Portrait of Sylvette David*, 1954 (cat. 204). The Art Institute of Chicago, gift of Mary and Leigh Block, 1955.821.

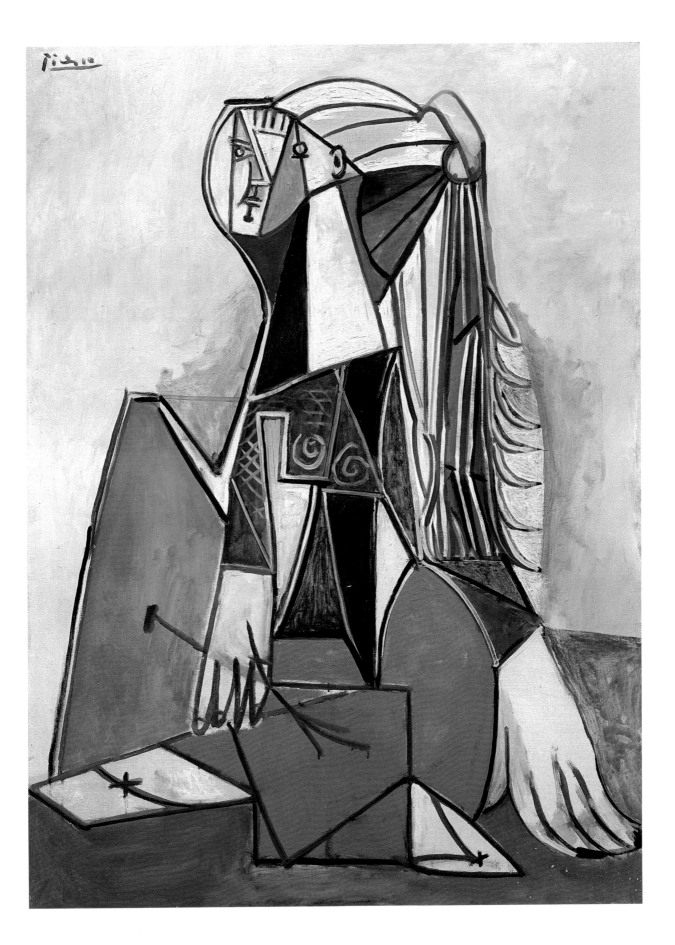

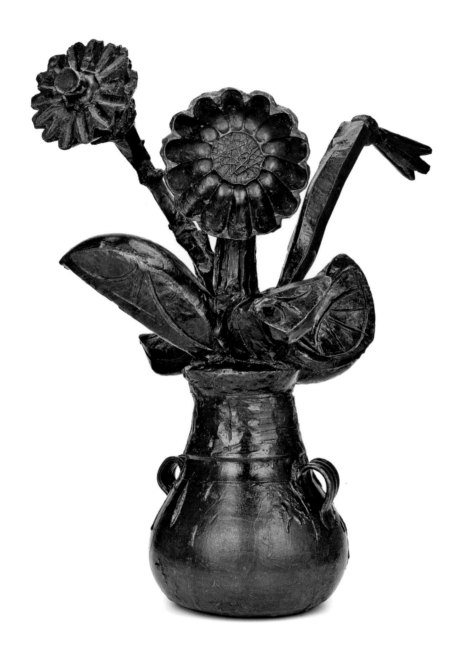

Plate 79. *Flowers in a Vase*, 1951 (cast 1953) (cat. 201). The Art Institute of Chicago, gift of Mr. and Mrs. Victor K. Zurcher, 1957.70.

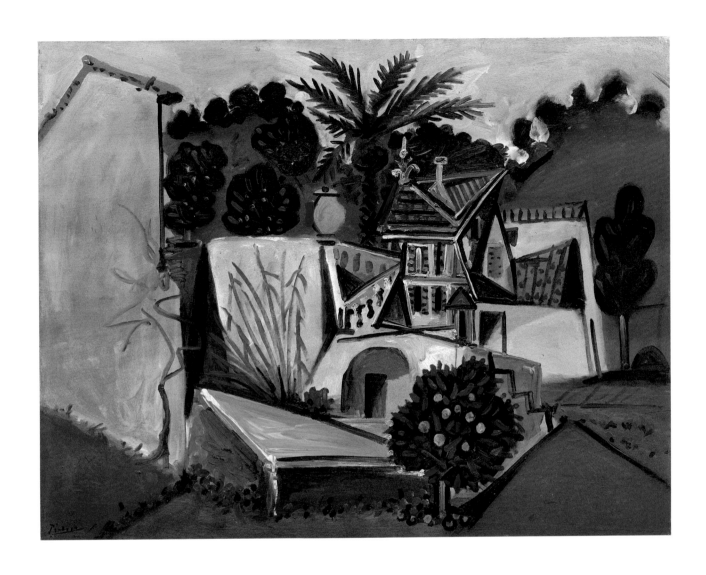

Plate 80. *Villa in Vallauris*, February 4, 1951 (cat. 202). The Art Institute of Chicago, gift of Mary and Leigh Block, 1988.141.21.

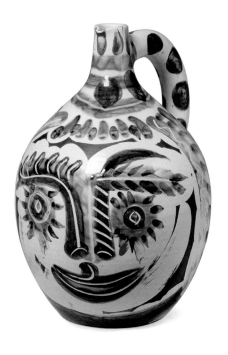

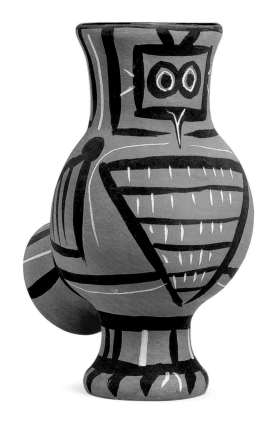

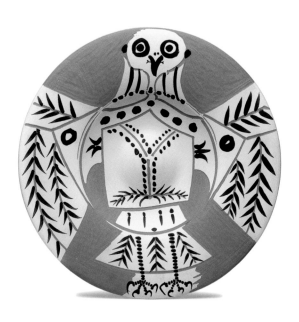

Plate 81. *Laughing-Eyed Face*, January 9, 1969 (cat. 249). Private collection.

Plate 82. *Matt Wood-Owl*, 1958 (cat. 208). Private collection.

Plate 83. *White Owl on Red Ground*, March 25, 1957 (cat. 207). Private collection.

Plate 84. *Large Vase with Dancers*, 1950 (cat. 200). Collection of Nancy and Steve Crown.

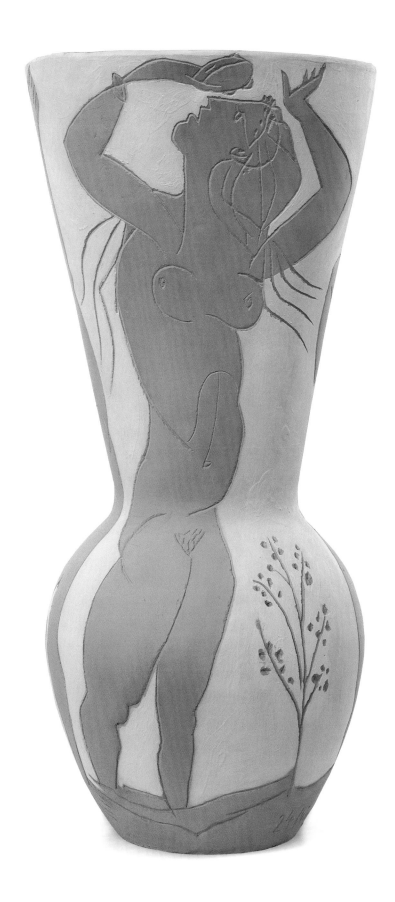

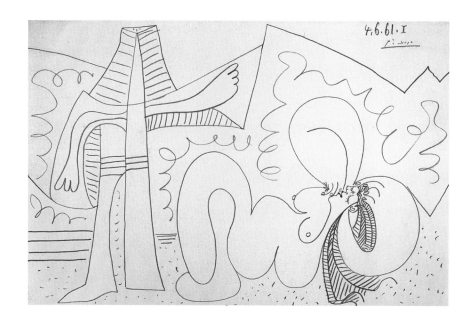

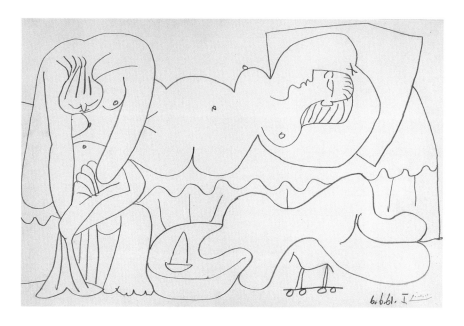

Plate 85. *Bathers*, June 4, 1961 (cat. 214). Ursula and R. Stanley Johnson Family Collection.
Plate 86. *Study for "Luncheon on the Grass" after Manet*, June 6, 1961 (cat. 215). Private collection.

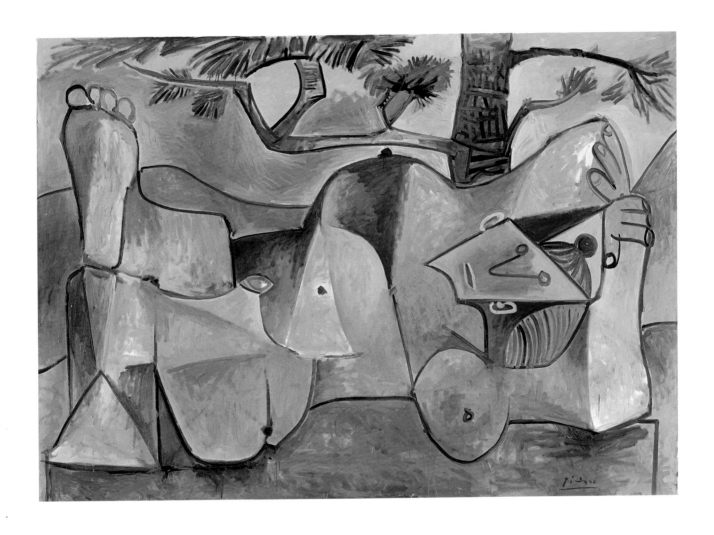

Plate 87. *Nude under a Pine Tree*, January 20, 1959 (cat. 211). The Art Institute of Chicago, bequest of Grant J. Pick, 1965.687.

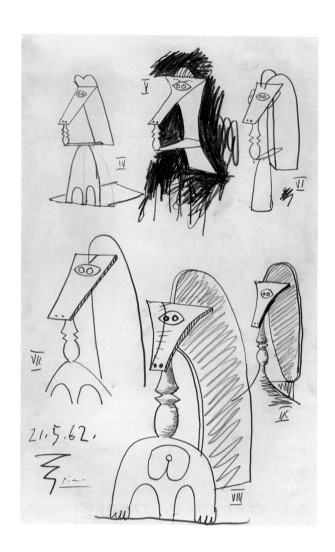

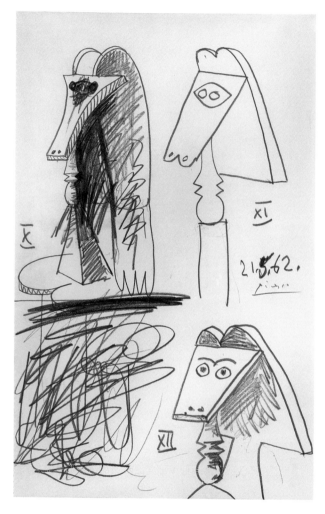

Plate 88. *Six Busts of Women*, May 21, 1962 (cat. 228). The Art Institute of Chicago, restricted gift of William E. Hartmann, 1967.539.
Plate 89. *Three Busts of Women*, May 21, 1962 (cat. 226). Private collection.

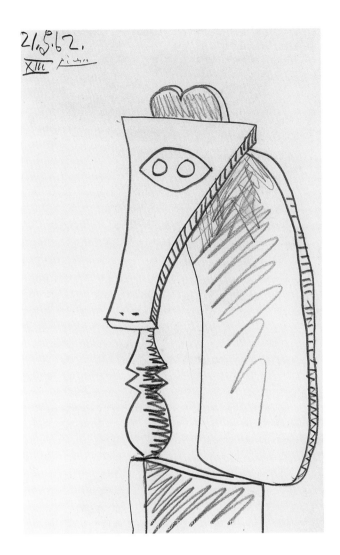

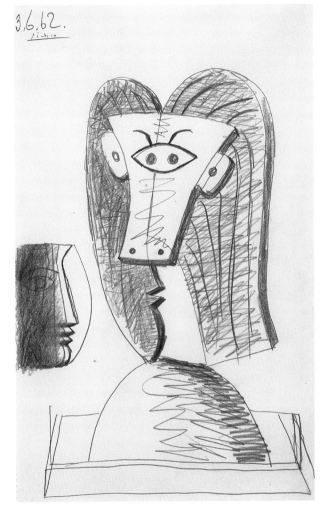

Plate 90. *Head of a Woman*, May 21, 1962 (cat. 227). Private collection.
Plate 91. *Head of a Woman*, June 3, 1962 (cat. 229). Ursula and R. Stanley Johnson Family Collection.

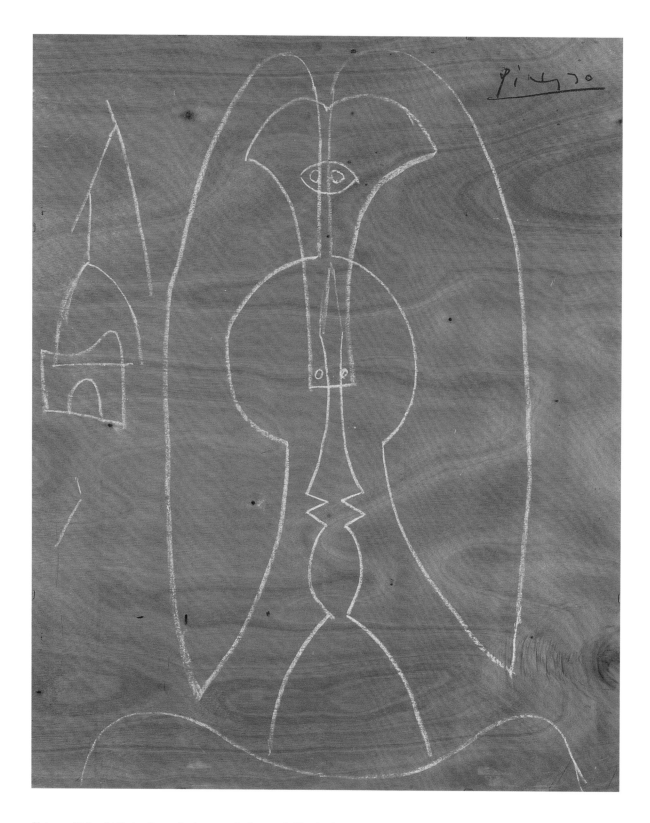

Plate 92. *Richard J. Daley Center Sculpture*, 1967 (cat. 245). The Art Institute of Chicago, gift of Pablo Picasso, 1967.538.

Plate 93. *Maquette for Richard J. Daley Center Sculpture*, 1964 (cat. 231). The Art Institute of Chicago, gift of Pablo Picasso, 1966.379.

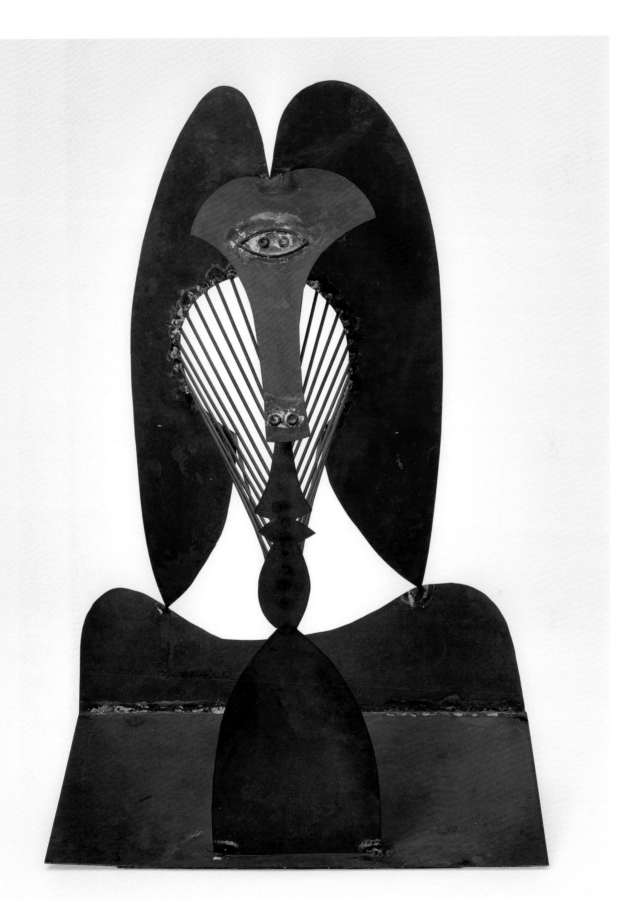

Plate 94. *Seated Nude II*, July 17, 1967 (cat. 247). Private collection.

Plate 95. *Rooster, Woman, and Young Man*, September 4, 1967 (cat. 248). Ursula and R. Stanley Johnson Family Collection.

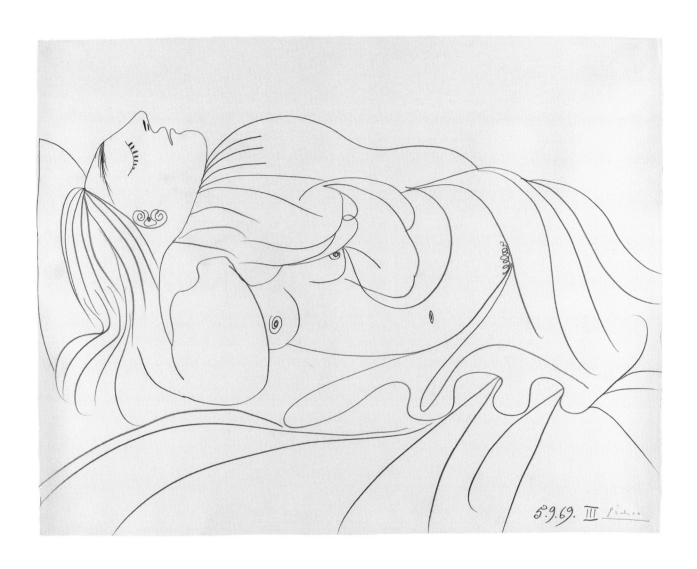

Plate 96. *Reclining Nude (Sleeping Woman)*, September 5, 1969 (cat. 251). The Art Institute of Chicago, promised gift of Richard and Mary L. Gray and the Gray Collection Trust.

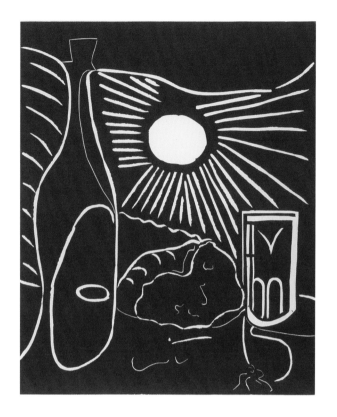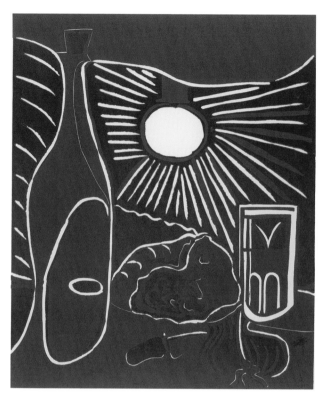

Plate 97. *Still Life with Lunch I*, 1962 (cat. 218). The Art Institute of Chicago, Stacia Fischer Bequest Fund, 2004.1118.
Plate 98. *Still Life with Lunch I*, 1962 (cat. 221). The Art Institute of Chicago, Stacia Fischer Bequest Fund, 2004.1121.

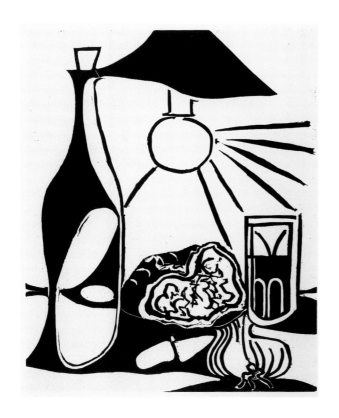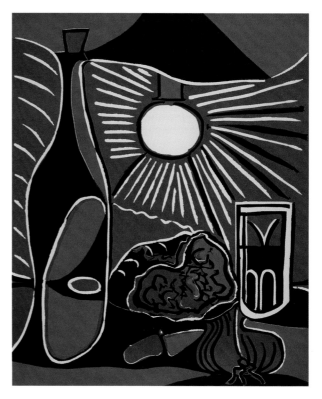

Plate 99. *Still Life with Lunch II*, 1962 (cat. 223). The Art Institute of Chicago, Stacia Fischer Bequest Fund, 2004.1123.
Plate 100. *Still Life with Lunch I*, 1962 (cat. 222). The Art Institute of Chicago, gift of Frederick Mulder, 2008.553.

CATALOGUE OF THE EXHIBITION

1. *Josep Cardona*, Barcelona, 1899. Charcoal with stumping, dilute oil wash, and black watercolor on ivory laid paper; 26.9 x 25.5 cm. Private collection. Plate 1.

2. *Young Woman with a Hat*, Paris, 1900. Pastel, with stumping and incising, over charcoal on gray millboard; 36.5 x 27 cm. The Art Institute of Chicago, bequest of Joseph Winterbotham, 1954.319.

3. *At the Cabaret*, Paris, 1901. Black, orange, and blue crayon on paper; 12.5 x 21.5 cm. The Art Institute of Chicago, Mr. and Mrs. Lewis Larned Coburn Memorial Collection, 1933.527.

4. *Old Woman (Woman with Gloves)*, 1901. Oil on cardboard; 67 x 52.1 cm. Philadelphia Museum of Art, the Louise and Walter Arensberg Collection, 1950, 1950–134–158. Plate 3.

5. *Crazy Woman with Cats*, Paris, early summer 1901. Oil on cardboard; 44.3 x 40.8 cm. The Art Institute of Chicago, Amy McCormick Memorial Collection, 1942.464. Plate 2.

6. *The Old Guitarist*, Barcelona, late 1903–early 1904. Oil on panel; 122.9 x 82.6 cm. The Art Institute of Chicago, Helen Birch Bartlett Memorial Collection, 1926.253. Plate 4.

7. *Woman with a Helmet of Hair*, Paris, 1904. Gouache on tan, wood pulp board; 42.7 x 31.3 cm. The Art Institute of Chicago, bequest of Kate L. Brewster, 1950.128. Plate 6.

8. *Beggar with Crutch*, Barcelona, 1904. Pen and brown ink and colored crayon on tan paper; 36.8 x 23.7 cm. The Art Institute of Chicago, bequest of Mrs. Gordon Palmer, 1985.466.

9. *Sketches of a Young Woman and a Man*, Paris, 1904. Pen and brush and black ink on tan paper; 25.3 x 33.5 cm. The Art Institute of Chicago, gift of Robert Allerton, 1923.1058.

10. *The Frugal Meal*, from *The Saltimbanques*, September 1904. Etching in blue-green on paper; 48 x 38 cm (image/plate); 57.5 x 43.8 cm (sheet). The Art Institute of Chicago, Clarence Buckingham Collection, 1963.825. Plate 5.

11. *The Frugal Meal*, from *The Saltimbanques*, September 1904. Etching on paper; 46.2 x 37.8 cm (image/plate); 60 x 44 cm (sheet). The Art Institute of Chicago, Alfred Stieglitz Collection, 1949.904.

12. *Woman in Profile*, Paris, c. 1904. Pen and brown ink, and watercolor with blotting, on paper; 17.4 x 11.3 cm. The Art Institute of Chicago, bequest of Mrs. Gordon Palmer, 1985.454.

13. *Salomé*, from *The Saltimbanques*, 1905, printed and published 1913. Drypoint on paper; 29.5 x 32.2 cm (image); 40.2 x 34.7 cm (plate); 63.7 x 49.4 cm (sheet). The Art Institute of Chicago, Albert H. Wolf Memorial Collection, 1935.55.

14. *Head of a Woman in Profile*, from *The Saltimbanques*, 1905, printed and published 1913. Drypoint on paper; 29.1 x 19 cm (image); 29.1 x 25 cm (plate); 54.9 x 44.7 cm (sheet). The Art Institute of Chicago, gift of Walter S. Brewster, 1948.325.

15. *The Two Saltimbanques*, from *The Saltimbanques*, 1905, printed and published 1913. Drypoint on paper; 12 x 9.1 cm (plate); 14.9 x 11.6 cm (sheet, sight). The Art Institute of Chicago, collection of Francey and Dr. Martin L. Gecht, 53.2008. Plate 8.

16. *The Barbarous Dance (In Front of Salomé and Hérode)*, from *The Saltimbanques*, 1905. Drypoint on paper; 18.5 x 22.8 cm (plate); 22.2 x 30.8 cm (sheet, sight). The Art Institute of Chicago, collection of Francey and Dr. Martin L. Gecht, 54.2008.

17. *Study of a Seated Man*, Paris, 1905. Black chalk on paper (discolored to brown); 32.9 x 21.6 cm. The Art Institute of Chicago, gift of Robert Allerton, 1924.803. Plate 13.

18. *Head of a Woman, Madeleine*, from *The Saltimbanques*, January 1905, printed and published 1913. Etching on paper; 12 x 8.2 cm (image/plate); 41.8 x 28.7 cm (sheet). The Art Institute of Chicago, gift of Mr. and Mrs. Carl O. Schniewind, 1952.1213.

19. *Bust of a Man*, from *The Saltimbanques*, February 1905, printed and published 1913. Drypoint on paper; 11.9 x 8.9 cm (image/

plate); 43.5 x 33.5 cm (sheet). The Art Institute of Chicago, gift of Walter S. Brewster, 1951.325.

20. *Jester*, Paris, spring 1905. Bronze; 41.9 x 35.6 x 15.3 cm. The Art Institute of Chicago, Kate L. Brewster Collection, 1964.193. Plate 7.

21. *Female Nude*, 1906. Fabricated black chalk with graphite and smudging, on paper; 31.8 x 23.5 cm. Richard and Mary L. Gray and the Gray Collection Trust. Plate 15.

22. *Study for "La Coiffure,"* Paris, 1906. Pen and brown ink, with colored crayon and charcoal applied with stump, over graphite on blue-gray paper (discolored to brown); 18.4 x 30.7 cm (max., sheet irregularly cut). The Art Institute of Chicago, Ada Turnbull Hertle Fund, 1968.463. Plate 9.

23. *Head of a Woman with Chignon (Fernande)*, Gosol, summer 1906. Gouache on paper; 62 x 47 cm. Collection of Susan and Lew Manilow. Plate 18.

24. *Peasant Woman with a Shawl*, Gosol, summer 1906. Charcoal with stumping on paper; 63 x 42.4 cm. The Art Institute of Chicago, through prior bequest of Mrs. Gordon Palmer, 1986.1595. Plate 12.

25. *Fernande Olivier*, Gosol, summer 1906. Charcoal with stumping on paper; 61 x 45.8 cm. The Art Institute of Chicago, gift of Hermann Waldeck, 1951.210. Plate 17.

26. *Nude with a Pitcher*, Gosol, summer 1906. Oil on canvas; 100.6 x 81 cm. The Art Institute of Chicago, gift of Mary and Leigh Block, 1981.14. Plate 11.

27. *Peasant Girls from Andorra*, Paris, late summer 1906. Pen and brown ink over charcoal on paper; 63.5 x 43.5 cm. The Art Institute of Chicago, gift of Robert Allerton, 1930.933. Plate 10.

28. *Two Nudes, Standing*, Paris, fall 1906. Graphite with stumping on paper; 63 x 46.9 cm. The Art Institute of Chicago, gift of Mrs. Potter Palmer, 1944.575. Plate 16.

29. *Half-Length Female Nude*, Paris, fall 1906. Oil on canvas; 81.6 x 65.4 cm. The Art Institute of Chicago, gift of Florene May Schoenborn and Samuel A. Marx, 1959.619. Plate 14.

30. *Bust of a Young Woman*, fall 1906, printed January 1933. Woodcut on brown paper; 52.5 x 34.5 cm (image/sheet). The Art Institute of Chicago, Print and Drawing Club Fund, 1951.197.

31. *Study of Four Nudes*, Paris, 1906–07. Black crayon on paper; 13 x 20 cm. Ursula and R. Stanley Johnson Family Collection.

32. *Two Nude Figures: Woman with a Guitar and Boy with a Cup*, 1909. Drypoint with plate tone on paper; 13 x 11 cm (image/plate); 24 x 15.6 cm (sheet). The Art Institute of Chicago, Clarence Buckingham Collection, 1983.771.

33. *Two Nude Figures: Woman with a Guitar and Boy with a Cup*, 1909. Drypoint with plate tone on paper; 24.1 x 15.7 cm (sheet). The Art Institute of Chicago, Clarence Buckingham Collection, 1983.772.

34. *Two Nude Figures: Woman with a Guitar and Boy with a Cup*, 1909. Drypoint with plate tone on paper; 24.3 x 16 cm (sheet). The Art Institute of Chicago, Clarence Buckingham Collection, 1983.773.

35. *Two Nude Figures: Woman with a Guitar and Boy with a Cup*, 1909. Drypoint with black crayon and scraping and burnishing on paper; 13 x 11 cm (primary support). The Art Institute of Chicago, Clarence Buckingham Collection, 1983.774.

36. *Two Nude Figures: Woman with a Guitar and Boy with a Cup*, 1909. Drypoint with plate tone on paper; 13 x 11 cm (image/plate); 30.5 x 22.4 cm (sheet). The Art Institute of Chicago, Clarence Buckingham Collection, 1983.775.

37. *Two Nude Figures: Woman with a Guitar and Boy with a Cup*, 1909, printed 1911, published 1912. Drypoint with plate tone on paper; 13 x 11 cm (image/plate); 25 x 21 cm

(sheet). The Art Institute of Chicago, Clarence Buckingham Collection, 1983.776.

38. *Head of a Woman*, Paris, 1909. Gouache, watercolor, and black and ochre chalk with stump and wet brush on paper; 62.5 x 48 cm. The Art Institute of Chicago, Edward E. Ayer Endowment Fund in memory of Charles L. Hutchinson, 1945.136. Plate 24.

39. *Seated Female Nude*, Paris, summer 1909. Watercolor and gouache over graphite on paper; 64 x 49 cm. The Art Institute of Chicago, gift of Florene May Schoenborn and Samuel A. Marx, 1953.192. Plate 27.

40. *Head of a Woman*, Horta de Ebro, summer 1909. Oil on canvas; 60.3 x 51.1 cm. The Art Institute of Chicago, Joseph Winterbotham Collection, 1940.5. Plate 19.

41. *Head of a Woman (Fernande)*, Paris, fall 1909 (cast 1910). Bronze, one of two casts; 40.7 x 20.1 x 26.9 cm. The Art Institute of Chicago, Alfred Stieglitz Collection, 1949.584. Plate 22.

42. *Head of a Woman*, Paris, fall 1909. Watercolor on paper; 33.2 x 25.6 cm. The Art Institute of Chicago, Alfred Stieglitz Collection, 1949.578. Plate 23.

43. *Still Life with Bottle*, Paris, fall 1909. Watercolor and pen and brown ink, with charcoal and scraping, on paper; 33.6 x 51.1 cm. The Art Institute of Chicago, gift of William M. Eisendrath, Jr., 1940.1047R. Plate 25.

44. *Bust of a Woman*, Paris, late 1909. Watercolor and gouache on paper; 31.6 x 23.4 cm. The Art Institute of Chicago, gift of Mr. and Mrs. Roy J. Friedman, 1964.215. Plate 21.

45. *Head of a Woman (Fernande)*, Paris, winter 1909–10. Brush and gray wash on paper; 31.1 x 23.8 cm. Private collection. Plate 20.

46. *Daniel-Henry Kahnweiler*, Paris, fall 1910. Oil on canvas; 100.4 x 72.4 cm. The Art Institute of Chicago, gift of Mrs. Gilbert W. Chapman in memory of Charles B. Goodspeed, 1948.561. Plate 28.

47. *Still Life with Bottle of Marc*, August 1911, published 1912. Drypoint on paper; 50 x 30.6 cm (image/plate); 72 x 55.1 cm (sheet). The Art Institute of Chicago, John H. Wrenn Memorial Collection, 1957.353.

48. *Fan*, Ceret, summer 1911. Pen and brown ink, brush and brown wash on paper; 28.5 x 22 cm. Ursula and R. Stanley Johnson Family Collection. Plate 30.

49. *Man with Clarinet*, Ceret, summer 1911. Fabricated black chalk on paper; 30.9 x 19.6 cm. Richard and Mary L. Gray and the Gray Collection Trust. Plate 29.

50. *The Glass*, Paris, 1911/12. Oil on canvas; 33 x 17.6 cm. The Art Institute of Chicago, gift of Claire B. Zeisler in memory of A. James Speyer, 1986.1410.

51. *Mustachioed Man with a Guitar*, Ceret, 1912. Graphite with smudging on paper; 30.5 x 19.4 cm. The Art Institute of Chicago, collection of Francey and Dr. Martin L. Gecht, 55.2008. Plate 26.

52. *Woman with Zither*, c. 1913–14. Graphite on paper; 64 x 47 cm. Ursula and R. Stanley Johnson Family Collection.

53. *Man with a Pipe (Man with a Mustache, Buttoned Vest, and Pipe)*, Paris, 1915. Oil with sand on canvas; 129.8 x 88.5 cm. The Art Institute of Chicago, gift of Mrs. Leigh B. Block in memory of Albert D. Lasker, 1952.1116. Plate 32.

54. *Seated Woman in an Armchair*, Montrouge, 1915. Graphite with stumping on paper; 13.9 x 13.4 cm. The Art Institute of Chicago, Dorothy Braude Edinburg Art LLC, 409.2010. Plate 31.

55. *Woman in an Armchair*, Montrouge, 1916. Watercolor and gouache with graphite on paper; 15.1 x 12.4 cm. The Art Institute of Chicago, gift of Robert Allerton, 1927.545.

56. *Head of Harlequin*, 1916. Graphite on tan paper; 12.7 x 10.1 cm. The Art Institute of Chicago, Dorothy Braude Edinburg Art LLC, 408.2010. Plate 33.

57. *Harlequin Playing the Guitar*, Paris, c. 1916. Graphite on paper; 30.5 x 24.1 cm. Collection of Richard and Gail Elden. Plate 34.

58. *Harlequin*, 1917. Gouache on paper; 64.8 x 48.3 cm. The Art Institute of Chicago, anonymous loan, 10.2002.

59. *Woman in an Armchair*, Biarritz, 1918. Graphite, watercolor, and gouache on paper; 27.5 x 19.9 cm. The Art Institute of Chicago, gift of Dorothy Braude Edinburg to the Harry B. and Bessie K. Braude Memorial Collection, 1998.717.

60. *Pierrot and Harlequin*, Montrouge, 1918. Graphite on paper; 26.5 x 19.5 cm. The Art Institute of Chicago, given in memory of Charles Barnett Goodspeed by Mrs. Charles B. Goodspeed, 1947.875. Plate 36.

61. *Pierrot*, Montrouge, 1918. Graphite with erasing on paper; 34.1 x 25 cm. The Art Institute of Chicago, gift of Dorothy Braude Edinburg to the Harry B. and Bessie K. Braude Memorial Collection, 1998.718. Plate 35.

62. *Woman, Amor, and Harlequin Playing the Guitar*, Biarritz, 1918. Graphite with erasing on paper; 31.1 x 23 cm. The Art Institute of Chicago, Dorothy Braude Edinburg Art LLC, 410.2010.

63. *Léonide Massine*, London, 1919. Graphite with smudging and erasing on paper; 39.9 x 31.3 cm. The Art Institute of Chicago, Margaret Day Blake Collection, 1972.970. Plate 37.

64. *Dancer*, London, 1919. Graphite with erasing on paper (discolored to tan); 31.1 x 23.7 cm. The Art Institute of Chicago, bequest of Mrs. Richard Q. Livingston, 1993.291. Plate 38.

65. *Nude Reclining on the Beach*, Juan-les-Pins, June 19, 1920. Graphite and pastel on paper; 21 x 27 cm (sheet). Collection of Richard and Gail Elden. Plate 39.

66. *Three Nudes Reclining on a Beach*, Juan-les-Pins, June 22, 1920. Graphite on paper; 49 x 62.4 cm. The Art Institute of Chicago, gift of Dorothy Braude Edinburg to the Harry B. and Bessie K. Braude Memorial Collection, 1998.719. Plate 40.

67. *Study for "Three Musicians"* (also known as *The White Table*), Juan-les-Pins, August 29, 1920. Gouache on paper; 26.1 x 21 cm. Ursula and R. Stanley Johnson Family Collection.

68. *Nessus and Deianira*, Juan-les-Pins, September 22, 1920. Graphite on paper, prepared with a white ground; 21.5 x 27 cm. The Art Institute of Chicago, Clarence Buckingham Collection, 1965.783. Plate 42.

69. *Mother and Child*, Paris, 1921. Oil on canvas; 142.7 x 172.5 cm. The Art Institute of Chicago, restricted gift of Maymar Corporation, Mrs. Maurice L. Rothschild, and Mr. and Mrs. Chauncey McCormick; Mary and Leigh Block Fund; Ada Turnbull Hertle Endowment; through prior gift of Mr. and Mrs. Edwin E. Hokin, 1954.270. Plate 41.

70. *Fragment of "Mother and Child,"* Paris, 1921. Oil on canvas; 142.9 x 44.5 cm. The Art Institute of Chicago, gift of Pablo Picasso, 1968.100. Plate 41a.

71. *The Cavalier*, from *Four Lithographs*, March 7, 1921, published April 1923. Lithograph on paper; 19.5 x 27 cm (image); 23 x 27.8 cm (sheet). The Art Institute of Chicago, restricted gift of the Alsdorf Foundation, 1968.189.

72. *On the Beach I (Two Nude Women)*, from *Four Lithographs*, March 8, 1921, published April 1923. Lithograph on paper; 9.8 x 22 cm (image); 22.6 x 27.8 cm (sheet). The Art Institute of Chicago, Albert H. Wolf Memorial Collection, 1935.57.

73. *Head of a Woman*, 1922. Red and black chalk with red chalk wash on tan paper; 62.1 x 48.2 cm. The Arts Club of Chicago, Arts Club Purchase Fund, 1926. Plate 44.

74. *Woman Standing with One Arm behind Her Head*, Dinard, 1922. Graphite with erasing on paper; 34.3 x 23.9 cm. The Art Institute of Chicago, collection of Francey and Dr. Martin L. Gecht, 56.2008. Plate 43.

75. *Still Life*, Paris, February 4, 1922. Oil on canvas; 81.6 x 100.3 cm. The Art Institute of Chicago, Ada Turnbull Hertle Endowment, 1953.28. Plate 45.

76. *Guitar on a Table*, Juan-les-Pins, 1924. Watercolor and graphite with gouache on paper; 15.5 x 20 cm. The Art Institute of Chicago, Dorothy Braude Edinburg Art LLC, 402.2010.

77. *Four Female Nudes*, Monte Carlo, 1925. Pen and ink on paper; 35 x 25 cm (sheet). Collection of Richard and Gail Elden.

78. *Two Dancers*, Monte Carlo, 1925. Pen and ink on tan woven paper; 35.2 x 25.2 cm. Richard and Mary L. Gray and the Gray Collection Trust.

79. *Head*, Cannes (?), 1927. Oil and chalk on canvas; 99.5 x 80.7 cm. The Art Institute of Chicago, gift of Florene May Schoenborn and Samuel A. Marx, 1951.185. Plate 49.

80. *Sculptor before His Sculpture, with a Young Girl in a Turban and Sculpted Head,* from *The Unknown Masterpiece*, 1927, printed and published 1931. Etching on paper; 19.2 x 27.7 cm (image/plate); 25 x 32.4 cm (sheet). Written by Honoré de Balzac (French, 1799–1850). The Art Institute of Chicago, gift of the Print and Drawing Club, 1946.440.1.

81. *Painter with Two Models Looking at a Canvas*, from *The Unknown Masterpiece*, 1927, printed and published 1931. Etching on paper; 19.2 x 27.6 cm (image/plate); 24.8 x 31.3 cm (sheet). Written by Honoré de Balzac (French, 1799–1850). The Art Institute of Chicago, gift of the Print and Drawing Club, 1946.440.2.

82. *Painter and Model Knitting*, from *The Unknown Masterpiece*, 1927, printed and published 1931. Etching on paper; 19.3 x 27.8 cm (image/plate); 25.2 x 32.3 cm (sheet). Written by Honoré de Balzac (French, 1799–1850). The Art Institute of Chicago, gift of the Print and Drawing Club, 1946.440.4.

83. *Sculptor with Sculpture and Other Works*, from *The Unknown Masterpiece*, 1927, printed and published 1931. Etching on paper; 19.2 x 27.6 cm (image/plate); 25.2 x 32 cm (sheet). Written by Honoré de Balzac (French,

1799–1850). The Art Institute of Chicago, gift of the Print and Drawing Club, 1946.440.5.

84. *Bald Painter before His Easel*, from *The Unknown Masterpiece*, 1927, printed and published 1931. Etching on paper; 19.4 x 27.6 cm (image/plate); 25.1 x 32.4 cm (sheet). Written by Honoré de Balzac (French, 1799–1850). The Art Institute of Chicago, gift of the Print and Drawing Club, 1946.440.6.

85. *Three Standing Nudes, with Sketches of Faces*, from *The Unknown Masterpiece*, 1927, printed and published 1931. Etching on paper; 19.3 x 25.6 cm (image); 19.3 x 27.7 cm (plate); 25 x 31.7 cm (sheet). Written by Honoré de Balzac (French, 1799–1850). The Art Institute of Chicago, gift of the Print and Drawing Club, 1946.440.9.

86. *Painter before His Painting*, from *The Unknown Masterpiece*, 1927, printed and published 1931. Etching on paper; 27.6 x 19.4 cm (image/plate); 33 x 25 cm (sheet). Written by Honoré de Balzac (French, 1799–1850). The Art Institute of Chicago, gift of the Print and Drawing Club, 1946.440.11.

87. *Painter before His Easel with a Long-Haired Model*, from *The Unknown Masterpiece*, 1927, printed and published 1931. Etching on paper; 27.5 x 19.2 cm (image/plate); 32.3 x 24.8 cm (sheet). Written by Honoré de Balzac (French, 1799–1850). The Art Institute of Chicago, gift of the Print and Drawing Club, 1946.440.12.

88. *Painter Picking Up His Brush, with a Model in a Turban*, from *The Unknown Masterpiece*, 1927–28, printed and published 1931. Etching on paper; 19.4 x 27.5 cm (image/plate); 24.9 x 32.5 cm (sheet). Written by Honoré de Balzac (French, 1799–1850). The Art Institute of Chicago, gift of the Print and Drawing Club, 1946.440.7.

89. *Painter Working Observed by Nude Model*, from *The Unknown Masterpiece*, 1927–28, printed and published 1931. Etching on paper; 19.2 x 27.7 cm (image/plate); 24.7 x 32 cm (sheet). Written by Honoré de Balzac

(French, 1799–1850). The Art Institute of Chicago, gift of the Print and Drawing Club, 1946.440.8.

90. *Face of Marie-Thérèse*, 1928. Lithograph on paper; 20.4 x 14 cm (image); 44.3 x 33 cm (sheet). The Art Institute of Chicago, gift of Walter S. Brewster, 1952.1189.

91. *Seated Nude and Sketches (Horse, Bull . . .)*, from *The Unknown Masterpiece*, probably 1928, printed and published 1931. Etching on paper; 18.4 x 26 cm (image); 19.2 x 27.7 cm (plate); 25.2 x 32.6 cm (sheet). Written by Honoré de Balzac (French, 1799–1850). The Art Institute of Chicago, gift of the Print and Drawing Club, 1946.440.10.

92. *Bull and Horse in the Arena*, from *The Unknown Masterpiece*, probably 1929, printed and published 1931. Etching on paper; 18 x 27.1 cm (image); 19.3 x 27.7 cm (plate); 24.8 x 32.8 cm (sheet). Written by Honoré de Balzac (French, 1799–1850). The Art Institute of Chicago, gift of the Print and Drawing Club, 1946.440.3.

93. *Abstraction: Background with Blue Cloudy Sky*. Paris, January 4, 1930. Oil on panel; 66 x 49.1 cm. The Art Institute of Chicago, gift of Florene May Schoenborn and Samuel A. Marx; Wilson L. Mead Fund, 1955.748. Plate 47.

94. *Meleager Kills the Caledonian Boar*, from *Metamorphoses*, September 18, 1930, published 1931. Etching on paper; 27 x 19.1 cm (image); 31.1 x 22.3 cm (plate); 32.8 x 25.7 cm (sheet). Written by Ovid (Roman, 43 B.C.–A.D. 17). The Art Institute of Chicago, given in memory of A. Peter Dewey, 1946.65.16.

95. *Death of Orpheus (third plate)*, from *Metamorphoses*, September 18, 1930, published 1931. Etching on paper; 27.5 x 17.7 cm (image); 31 x 22.2 cm (plate); 32.2 x 25.5 cm (sheet). Written by Ovid (Roman, 43 B.C.–A.D. 17). The Art Institute of Chicago, given in memory of A. Peter Dewey, 1946.65.22.

96. *Deucalion and Pyrrha Create a New Human Race*, from *Metamorphoses*, September

20, 1930, published 1931. Etching on paper; 27.8 x 17 cm (image); 31 x 22.2 cm (plate); 32.5 x 25 cm (sheet). Written by Ovid (Roman, 43 B.C.–A.D. 17). The Art Institute of Chicago, given in memory of A. Peter Dewey, 1946.65.2.

97. *Hercules Kills the Centaur Nessus*, from *Metamorphoses*, September 20, 1930, published 1931. Etching on paper; 27.9 x 18.9 cm (image); 31.2 x 22.3 cm (plate); 33 x 25.7 cm (sheet). Written by Ovid (Roman, 43 B.C.–A.D. 17). The Art Institute of Chicago, given in memory of A. Peter Dewey, 1946.65.18.

98. *The Fall of Phaeton with the Sun Chariot*, from *Metamorphoses*, September 20, 1930, published 1931. Etching on paper; 31 x 22.2 cm (image/plate); 32.5 x 25.2 cm (sheet). Written by Ovid (Roman, 43 B.C.–A.D. 17). The Art Institute of Chicago, given in memory of A. Peter Dewey, 1946.65.4.

99. *Minyas's Daughters Refuse to Recognize the God Bacchus*, from *Metamorphoses*, September 20, 1930, published 1931. Etching on paper; 28 x 21.2 cm (image); 30.9 x 22.2 cm (plate); 32.5 x 25.2 cm (sheet). Written by Ovid (Roman, 43 B.C.–A.D. 17). The Art Institute of Chicago, given in memory of A. Peter Dewey, 1946.65.8.

100. *Numa Follows the Lesson of Pythagoras*, from *Metamorphoses*, September 25, 1930, published 1931. Etching on paper; 27.7 x 19 cm (image); 31 x 22.2 cm (plate); 32.5 x 25.5 cm (sheet). Written by Ovid (Roman, 43 B.C.–A.D. 17). The Art Institute of Chicago, given in memory of A. Peter Dewey, 1946.65.30.

101. *Eurydice Stung by a Serpent (second plate)*, from *Metamorphoses*, October 11, 1930, published 1931. Etching on paper; 27.3 x 17.5 cm (image); 31 x 22.2 cm (plate); 33 x 25.4 cm (sheet). Written by Ovid (Roman, 43 B.C.–A.D. 17). The Art Institute of Chicago, given in memory of A. Peter Dewey, 1946.65.20.

102. *Struggle Between Tiresias and His Sister-In-Law Philomele (third plate)*, from *Metamorphoses*, October 18, 1930, published 1931. Etching on paper; 28.4 x 17.3 cm (image); 31 x

22.2 cm (plate); 32.6 x 25.2 cm (sheet). Written by Ovid (Roman, 43 B.C.–A.D. 17). The Art Institute of Chicago, given in memory of A. Peter Dewey, 1946.65.12.

103. *The Love of Jupiter and Semele (third plate)*, from *Metamorphoses*, October 25, 1930, published 1931. Etching on paper; 27.8 x 18.7 cm (image); 30.9 x 22.2 cm (plate); 32.5 x 25.7 cm (sheet). Written by Ovid (Roman, 43 B.C.–A.D. 17). The Art Institute of Chicago, given in memory of A. Peter Dewey, 1946.65.6.

104. *The Unknown Masterpiece*, published 1931. Twelve etchings and 67 wood engravings, with black morocco binding with irregular mosaic; 33.3 x 26.2 x 4.4 cm. Written by Honoré de Balzac (French, 1799–1850). The Art Institute of Chicago, bequest of Maxine Kunstadter, 1978.645.

105. *Profile and Head of a Woman*, from *Metamorphoses*, published 1931. Etching on paper; 24.1 x 17 cm (image); 32.8 x 24.6 cm (sheet, no plate mark). Written by Ovid (Roman, 43 B.C.–A.D. 17). The Art Institute of Chicago, given in memory of A. Peter Dewey, 1946.65.3.

106. *Heads*, from *Metamorphoses*, published 1931. Etching on paper; 30 x 20.1 cm (image); 33 x 25.5 cm (sheet, no plate mark). Written by Ovid (Roman, 43 B.C.–A.D. 17). The Art Institute of Chicago, given in memory of A. Peter Dewey, 1946.65.5.

107. *Arachne Showing Her Work*, from *Metamorphoses*, published 1931. Etching on paper; 20.1 x 17.4 cm (image); 33.1 x 25.5 cm (sheet). Written by Ovid (Roman, 43 B.C.–A.D. 17). The Art Institute of Chicago, given in memory of A. Peter Dewey, 1946.65.11.

108. *Three Fragments of Heads*, from *Metamorphoses*, published 1931. Etching on paper; 22.1 x 17.2 cm (image); 32.7 x 25.4 cm (sheet). Written by Ovid (Roman, 43 B.C.–A.D. 17). The Art Institute of Chicago, given in memory of A. Peter Dewey, 1946.65.17.

109. *Four Women in Flight*, from *Metamorphoses*, published 1931. Etching on paper; 20.9 x

17.3 cm (image); 32.9 x 25.1 cm (sheet). Written by Ovid (Roman, 43 B.C.–A.D. 17). The Art Institute of Chicago, given in memory of A. Peter Dewey, 1946.65.19.

110. *Two Wrestlers Observed by Three Nude Women*, from *Metamorphoses*, published 1931. Etching on paper; 20.3 x 17.9 cm (image); 33 x 25.2 cm (sheet). Written by Ovid (Roman, 43 B.C.–A.D. 17). The Art Institute of Chicago, given in memory of A. Peter Dewey, 1946.65.23.

111. *Two Female Nudes I*, from *Metamorphoses*, published 1931. Etching on paper; 22.4 x 17.2 cm (image); 32.5 x 25.8 cm (sheet). Written by Ovid (Roman, 43 B.C.–A.D. 17). The Art Institute of Chicago, given in memory of A. Peter Dewey, 1946.65.25.

112. *Partial Female Figure*, from *Metamorphoses*, published 1931. Etching on paper; 21.1 x 19 cm (image); 32.7 x 25.4 cm (sheet). Written by Ovid (Roman, 43 B.C.–A.D. 17). The Art Institute of Chicago, given in memory of A. Peter Dewey, 1946.65.27.

113. *Two Heads of Women*, from *Metamorphoses*, published 1931. Etching on paper; 24.2 x 17.4 cm (image); 32.3 x 25.3 cm (sheet). Written by Ovid (Roman, 43 B.C.–A.D. 17). The Art Institute of Chicago, given in memory of A. Peter Dewey, 1946.65.29.

114. *The Red Armchair*, Paris, December 16, 1931. Oil and Ripolin on panel; 130 x 98 cm. The Art Institute of Chicago, gift of Mr. and Mrs. Daniel Saidenberg, 1957.72. Plate 56.

115. *Double Flute Player and Reclining Nude*, Paris, October 22, 1932. Pen and black ink with brush and black wash and scraping on paper; 25.9 x 33 cm. The Art Institute of Chicago, gift of Mr. and Mrs. Joseph R. Shapiro, 1992.260.

116. *Marie-Thérèse Seated on the Ground*, Paris, January 19, 1933. Drypoint and aquatint, with touches of brush and gray wash, over collaged cut-and-torn tracing paper toned with yellow and blue wash, on paper; 15.5 x 9.7 cm (image); 34.2 x 25.8 cm (sheet). Richard and Mary L. Gray and the Gray Collection Trust.

117. *Three Comedians with a Bust of Marie-Thérèse*, from *Vollard Suite*, March 14, 1933, printed 1939. Drypoint on parchment; 27.5 x 17.5 cm (image/plate); 45.5 x 33.8 cm (sheet). The Art Institute of Chicago, William McCallin McKee Memorial Collection, 1946.438.

118. *Model and Sculptor with His Sculpture*, from *Vollard Suite*, March 17, 1933, printed 1939. Etching on paper; 26.5 x 19.4 cm (image/plate); 44.5 x 34 cm (sheet). The Art Institute of Chicago, bequest of Maribel G. Blum, 1986.132.

119. *Sculptor Working on a Motif with Marie-Thérèse Posing*, from *Vollard Suite*, March 31, 1933, printed 1939. Etching on paper; 19.3 x 26.9 cm (image/plate); 33.9 x 44.2 cm (sheet). The Art Institute of Chicago, bequest of Maribel G. Blum, 1986.134.

120. *Marie-Thérèse Kneeling, Contemplating a Sculpted Group*, from *Vollard Suite*, April 5, 1933; printed 1939. Etching on paper; 29.7 x 36.7 cm (image/plate); 33.8 x 44 cm (sheet). The Art Institute of Chicago, bequest of Maribel G. Blum, 1986.135.

121. *The Embrace III*, from *Vollard Suite*, April 23, 1933, printed and published 1939. Drypoint on paper; 29.5 x 36.5 cm (image/plate); 34 x 45 cm (sheet). The Art Institute of Chicago, gift of Dennis Adrian, 1963.546.

122. *Sculptures Representing Marie-Thérèse and the Head of a Sculptor, with a Vase of Three Flowers*, from *Vollard Suite*, May 5, 1933, printed 1939. Etching on paper; 26.5 x 19 cm (image/plate); 44.8 x 34.5 cm (sheet). The Art Institute of Chicago, bequest of Janis H. Palmer, 1985.468.

123. *Bacchic Scene with Minotaur*, from *Vollard Suite*, May 18, 1933, printed 1939. Etching on paper; 29.7 x 36.8 cm (image/plate); 34 x 44.6 cm (sheet). The Art Institute of Chicago, restricted gift of Mrs. Albert Newman in memory of her mother, Ida Kallis, 1968.62.

124. *Minotaur in Love with a Woman Centaur*, from *Vollard Suite*, May 23, 1933, reworked 1934, printed 1939. Etching and drypoint on paper; 19 x 26.3 cm (image/plate); 34 x 44.4 cm (sheet). The Art Institute of Chicago, Prints and Drawings Purchase Account, 1969.32.

125. *Wounded Minotaur VI*, from *Vollard Suite*, May 26, 1933, printed 1939. Etching on paper; 19.2 x 26.9 cm (image/plate); 34 x 44.5 cm (sheet). The Art Institute of Chicago, gift of the Print and Drawing Club, 1967.532.

126. *Minotaur Caressing Sleeping Woman*, from *Vollard Suite*, June 18, 1933, printed 1939. Drypoint on paper; 29.5 x 36.5 cm (image/plate); 33.8 x 45 cm (sheet). The Art Institute of Chicago, gift of the Print and Drawing Club, 1957.331.

127. *The Minotaur*, Boisgeloup, June 24, 1933. Pen and brush and black ink and brush and gray wash on blue paper; 48 x 63 cm. The Art Institute of Chicago, Margaret Day Blake Collection, 1967.516. Plate 51.

128. *Artist and Model*, Cannes, July 24, 1933. Watercolor and pen and black ink on paper; 40.2 x 50.6 cm. Richard and Mary L. Gray and the Gray Collection Trust.

129. *Coupling I*, from *Vollard Suite*, November 2, 1933, printed 1939. Drypoint with sugar lift etching and aquatint on paper; 19.7 x 27.7 cm (image/plate); 34 x 44.5 cm (sheet). The Art Institute of Chicago, Harold Joachim Purchase Fund, 1968.63.

130. *Bullfight. Wounded Female Bullfighter III*, from *Vollard Suite*, November 8, 1933, printed and published 1939. Drypoint and etching with engraving on paper; 19.7 x 27.5 cm (image/plate); 31 x 38.2 cm (sheet). The Art Institute of Chicago, gift of Joseph R. Shapiro, 1955.547.

131. *Blind Minotaur Led by a Young Girl*, from *Vollard Suite*, Paris, 1934. Aquatint, scraper, drypoint, and burin on paper; 24.7 x 34.7 cm (image); 34 x 44.5 cm (sheet). Collection of Nancy and Steve Crown. Plate 52.

132. *Female Bullfighter. Last Kiss?*, June 12, 1934, printed April 1939. Etching on paper; 49.5 x 69 cm (image/plate); 56.7 x 77 cm (sheet). The Art Institute of Chicago, gift from the estate of Curt Valentin, 1955.623.

133. *Marie-Thérèse as Female Bullfighter*, from *Vollard Suite*, June 20, 1934. Etching on paper; 29.7 x 23.7 cm (image/plate); 44.4 x 34.2 cm (sheet). The Art Institute of Chicago, Mary MacDonald Ludgin Memorial Fund, 1968.190.

134. *The Great Bullfight with Female Bullfighter*, September 8, 1934, printed April 1939. Etching on paper; 49.5 x 69 cm (image/plate); 56.9 x 77.1 cm (sheet). The Art Institute of Chicago, gift from the estate of Curt Valentin, 1955.624.

135. *Blind Minotaur Led by Little Girl with Flowers*, from *Vollard Suite*, September 22, 1934, printed 1939. Drypoint with scraping and engraving on paper; 25.3 x 34.7 cm (image/plate); 33.8 x 44.6 cm (sheet). The Art Institute of Chicago, Prints and Drawings Purchase Account, 1970.150.

136. *Blind Minotaur Led in the Night by a Little Girl with a Pigeon*, from *Vollard Suite*, October 23, 1934. Etching on paper; 23.8 x 29.9 cm (image/plate); 34.2 x 45.3 cm (sheet). The Art Institute of Chicago, John H. Wrenn Memorial Endowment Fund, 1969.392.

137. *Blind Minotaur Led by a Little Girl with a Pigeon*, from *Vollard Suite*, November 4, 1934. Etching with engraving and scraping, on paper; 22.7 x 31.4 cm (image/plate); 33.5 x 44.5 cm (sheet). The Art Institute of Chicago, Prints and Drawings Purchase Account, 1969.31.

138. *Pensive Boy Watching a Sleeping Woman by Candlelight*, from *Vollard Suite*, November 18, 1934, printed and published 1939. Etching, aquatint, and engraving with scraping and burnishing on paper; 23.8 x 29.7 cm (image/plate); 33.8 x 44.6 cm (sheet). The Art Institute of Chicago, gift of Merrill Chase Galleries, 1979.677.

139. *The Tavern: Young Catalan Fisherman Recounting His Life to an Old Bearded Fisherman*, from *Vollard Suite*, November 29, 1934, printed and published 1939. Etching on parchment; 23.2 x 28.7 cm image/plate); 41.2 x 54 cm (sheet). The Art Institute of Chicago, Print and Drawing Fund No. 1 Income, 1965.788.

140. *Harpy with a Head of a Bull and Four Young Girls on a Tower Surmounted with a Black Flag*, from *Vollard Suite*, December 1934. Etching on paper; 23.8 x 29.8 cm (image/plate); 33.7 x 45 cm (sheet). The Art Institute of Chicago, gift of Mr. and Mrs. Samuel E. Johnson, 1967.537.

141. *Figure*, Paris, 1935. Wood, metal, plastic, nails, screws, paint, twine, paper, and concrete; 63.5 x 18 x 13.7 cm. The Art Institute of Chicago, Mary L. and Leigh B. Block, and Alyce and Edwin DeCosta and the Walter E. Heller Foundation endowments; through prior gifts of Mary L. and Leigh B. Block, 1988.428. Plate 48.

142. *Minotauromachia*, Boisgeloup, March 23–May 3, 1935. Etching with scraping and engraving on paper; 49.5 x 69.1 cm (image/plate); 57.4 x 77.1 cm (sheet). The Art Institute of Chicago, gift of Mrs. Helen Pauling Donnelley, 1947.160. Plate 50.

143. *Minotaur and Wounded Horse*, April 17, 1935. Pen and brush and black ink, graphite, and colored crayon, with smudging, over incising on paper; 34.3 x 51.5 cm. The Art Institute of Chicago, anonymous gift, 1991.673. Plate 54.

144. *The Lizard*, from *Original Etchings for the Texts of Buffon*, 1936, published May 26, 1942. Aquatint, sugar lift etching, and drypoint on paper; 27 x 21.5 cm (image); 37 x 27.7 cm (sheet). Written by Georges-Louis Leclerc, comte de Buffon (French, 1707–1788). The Art Institute of Chicago, Print Sales Miscellaneous Fund, 1946.439.28.

145. *The Frogs*, from *Original Etchings for the Texts of Buffon*, 1936, published May 26, 1942.

Aquatint and sugar lift etching with scraping and drypoint on paper; 27 x 22.2 cm (image); 37 x 28 cm (sheet). Written by Georges-Louis Leclerc, comte de Buffon (French, 1707–1788). The Art Institute of Chicago, Print Sales Miscellaneous Fund, 1946.439.30.

146. *The Cat*, from *Original Etchings for the Texts of Buffon*, 1936, published May 26, 1942. Aquatint and sugar lift etching with scraping and drypoint on paper; 27 x 20.5 cm (image); 37.1 x 28.3 cm (sheet). Written by Georges-Louis Leclerc, comte de Buffon (French, 1707–1788). The Art Institute of Chicago, Print Sales Miscellaneous Fund, 1946.439.6.

147. *The Dog*, from *Original Etchings for the Texts of Buffon*, 1936, published May 26, 1942. Aquatint and sugar lift etching with drypoint on paper; 27 x 21.3 cm (image); 37 x 27.6 cm (sheet). Written by Georges-Louis Leclerc, comte de Buffon (French, 1707–1788). The Art Institute of Chicago, Print Sales Miscellaneous Fund, 1946.439.7.

148. *The Goat*, from *Original Etchings for the Texts of Buffon*, 1936, published May 26, 1942. Aquatint and sugar lift etching with scraping and drypoint on paper; 27 x 20.8 cm (image); 36.5 x 28 cm (sheet). Written by Georges-Louis Leclerc, comte de Buffon (French, 1707–1788). The Art Institute of Chicago, Print Sales Miscellaneous Fund, 1946.439.8.

149. *The Wolf*, from *Original Etchings for the Texts of Buffon*, 1936, published May 26, 1942. Aquatint and sugar lift etching on paper; 34.2 x 24.5 cm (image); 38 x 28.3 cm (sheet). Written by Georges-Louis Leclerc, comte de Buffon (French, 1707–1788). The Art Institute of Chicago, Print Sales Miscellaneous Fund, 1946.439.10.

150. *The Vulture*, from *Original Etchings for the Texts of Buffon*, 1936, published May 26, 1942. Aquatint and sugar lift etching with drypoint on paper; 31.5 x 20.5 cm (image); 37.2 x 28.3 cm (sheet). Written by Georges-Louis Leclerc, comte de Buffon (French, 1707–1788). The Art Institute of Chicago, Print Sales Miscellaneous Fund, 1946.439.14.

151. *The Ostrich*, from *Original Etchings for the Texts of Buffon*, 1936, published May 26, 1942. Aquatint and etching on paper; 26.6 x 22 cm (image); 36.2 x 28 cm (sheet). Written by Georges-Louis Leclerc, comte de Buffon (French, 1707–1788). The Art Institute of Chicago, Print Sales Miscellaneous Fund, 1946.439.16.

152. *The Turkey*, from *Original Etchings for the Texts of Buffon*, 1936, published May 26, 1942. Aquatint and sugar lift etching with scraping and drypoint on paper; 27.5 x 23 cm (image); 36.2 x 27.2 cm (sheet). Written by Georges-Louis Leclerc, comte de Buffon (French, 1707–1788). The Art Institute of Chicago, Print Sales Miscellaneous Fund, 1946.439.19.

153. *The Wasp*, from *Original Etchings for the Texts of Buffon*, 1936, published May 26, 1942. Aquatint and sugar lift etching with scraping and drypoint on paper; 29.2 x 22.0 cm (image); 36.9 x 28.5 cm (sheet). Written by Georges-Louis Leclerc, comte de Buffon (French, 1707–1788). The Art Institute of Chicago, Print Sales Miscellaneous Fund, 1946.439.24.

154. *The Lobster*, from *Original Etchings for the Texts of Buffon*, 1936, published May 26, 1942. Aquatint and sugar lift etching with drypoint on paper; 30 x 21.5 cm (image); 36.7 x 27.9 cm (sheet). Written by Georges-Louis Leclerc, comte de Buffon (French, 1707–1788). The Art Institute of Chicago, Print Sales Miscellaneous Fund, 1946.439.25.

155. *The Dragonfly*, from *Original Etchings for the Texts of Buffon*, 1936, published May 26, 1942. Aquatint and sugar lift etching with scraping and drypoint on paper; 27 x 21 cm (image); 37 x 27.2 cm (sheet). Written by Georges-Louis Leclerc, comte de Buffon (French, 1707–1788). The Art Institute of Chicago, Print Sales Miscellaneous Fund, 1946.439.27.

156. *The Ram*, from *Original Etchings for the Texts of Buffon*, 1936, published May 26, 1942. Aquatint and sugar lift etching with scraping and drypoint on paper; 27.1 x 21 cm (image);

36.5 x 27.8 cm (sheet). Written by Georges-Louis Leclerc, comte de Buffon (French, 1707–1788). The Art Institute of Chicago, Print Sales Miscellaneous Fund, 1946.439.5.

157. *The Monkey*, from *Original Etchings for the Texts of Buffon*, February 9, 1936, published May 26, 1942. Aquatint and sugar lift etching with scraping and drypoint on paper; 27.5 x 22 cm (image); 36.9 x 27.5 cm (sheet). Written by Georges-Louis Leclerc, comte de Buffon (French, 1707–1788). The Art Institute of Chicago, Print Sales Miscellaneous Fund, 1946.439.12.

158. *Faun Uncovering a Sleeping Woman (Jupiter and Antiope, after Rembrandt)*, from *Vollard Suite*, June 12, 1936. Aquatint and sugar lift etching with scraping and engraving on paper; 31.5 x 41 (image/plate); 34 x 44.5 cm (sheet). The Art Institute of Chicago, gift of Lesley Ryan Brown and her husband Alan J. Brown in commemoration of her citizenship, May 21, 1986, 1986.855. Plate 53.

159. Text and title page for *The Dream and Lie of Franco*, 1937. Portfolio cover with line block on paper, cut and laid down; 59.1 x 40 cm (cover, folded). The Art Institute of Chicago, anonymous gift, 1948.48.3.

160. *The Dream and Lie of Franco (Plate I)*, January 8, 1937. Aquatint and etching on paper; 31.7 x 42.1 cm (image/plate); 38 x 57 cm (sheet). The Art Institute of Chicago, anonymous gift, 1948.48.1.

161. *The Dream and Lie of Franco (Plate II)*, January 8–9, 1937, completed June 7, 1937. Etching and aquatint with scraping on paper; 31.7 x 42.1 cm (image/plate); 38 x 56.9 cm (sheet). The Art Institute of Chicago, anonymous gift, 1948.48.2.

162. *Portrait of Vollard II*, from *Vollard Suite*, March 4, 1937, printed and published 1939. Sugar lift with aquatint and spit-bite etching on paper; 34.7 x 24.6 cm (image/plate); 50.2 x 38.8 cm (sheet). The Art Institute of Chicago, Print and Drawing Purchase Fund, 1955.1113.

163. *Weeping Woman I*, July 1, 1937. Drypoint, aquatint, and etching, with scraping, on paper; 69.5 x 49.7 cm (plate); 77.4 x 56.8 cm (sheet). The Art Institute of Chicago, through prior acquisition of the Martin A. Ryerson Collection with the assistance of the Noel and Florence Rothman Family and the Margaret Fisher Endowment, 1994.707. Plate 59.

164. *Weeping Woman I*, Paris, July 1, 1937. Etching, aquatint, and drypoint, with scraper, on paper; 68.9 x 49.6 cm (plate); 72.8 x 53.4 cm (sheet). Gecht Family Art Collection. Plate 60.

165. *Weeping Woman III*, Paris, July 4, 1937. Drypoint, aquatint, and hand-corrosion on paper; 34.5 x 24.6 cm. Private collection. Plate 61.

166. *Weeping Woman IV*, Paris, July 4, 1937. Drypoint on paper; 34.7 x 25 cm. Private collection. Plate 62.

167. *Head of a Woman with Straw Hat on a Pink Background*, Paris, January 23, 1938. Oil on canvas; 63.5 x 48.9 cm. Private collection. Plate 55.

168. *Woman with Tambourine*, 1939, printed 1942, published 1943. Aquatint and etching with scraping on paper; 66.4 x 51.2 cm (image/plate); 76.5 x 56.9 cm (sheet). The Art Institute of Chicago, Print and Drawing Purchase Fund, 1961.32.

169. *Head of a Woman (Dora Maar)*, Paris, April 1, 1939. Oil on canvas; 92 x 73 cm. Private collection. Plate 58.

170. *Portrait of Nusch Éluard*, Paris, May 1941. Graphite with stumping, scraping, and incising on paper; 36.9 x 26.2 cm. The Art Institute of Chicago, Dorothy Braude Edinburg Art LLC, 404.2010. Plate 65.

171. *Seated Woman*, Paris, November 28, 1941. Pen and brown ink with brush and brown wash, and gouache, with wiping on paper; 40.8 x 30 cm. The Art Institute of Chicago, gift of Mr. and Mrs. Joseph R. Shapiro, 1996.636R.

172. *Bust of a Woman*, Paris, October 12, 1943. Oil on canvas; 92.1 x 59.1 cm. Collection of Sylvia Neil and Daniel Fischel. Plate 63.

173. *Woman Washing Her Feet*, Paris, May 6, 1944. Graphite with rubbing, erasing, and scraping, over incised lines, on paper, pierced; 50.7 x 38.6 cm. The Art Institute of Chicago, gift from the estate of Curt Valentin, 1955.603. Plate 57.

174. *Head of Young Boy*, August 13–15, 1944. Brush and black ink and gray wash, with scraping, on paper; 50 x 28.8 cm. The Art Institute of Chicago, bequest of Florene May Schoenborn, 2012.569. Plate 64.

175. *Bull I*, Paris, December 5, 1945. Lithograph on paper; 28.9 x 41 cm. Private collection.

176. *Bull II*, Paris, December 12, 1945. Lithograph on paper; 28.9 x 41 cm. Private collection. Plate 66.

177. *Bull III*, Paris, December 18, 1945. Lithograph on paper; 28.9 x 41 cm. Private collection.

178. *Bull IV*, Paris, December 22, 1945. Lithograph on paper; 28.9 x 41 cm. Private collection. Plate 67.

179. *Bull V*, Paris, December 24, 1945. Lithograph on paper; 28.9 x 41 cm. Private collection.

180. *Bull VI*, Paris, December 26, 1945. Lithograph on paper; 28.9 x 41 cm. Private collection.

181. *Bull VII*, Paris, December 28, 1945. Lithograph on paper; 28.9 x 41 cm. Private collection.

182. *Bull VIII*, Paris, January 2, 1946. Lithograph on paper; 28.9 x 41 cm. Private collection. Plate 68.

183. *Bull IX*, Paris, January 5, 1946. Lithograph on paper; 28.9 x 41 cm. Private collection.

184. *Bull X*, Paris, January 10, 1946. Lithograph on paper; 28.9 x 41 cm. Private collection.

185. *Bull XI*, Paris, January 17, 1946. Lithograph on paper; 28.9 x 41 cm. Private collection. Plate 69.

186. *Françoise*, June 14, 1946. Lithograph on paper; 65.4 x 50 cm (image/sheet). The Art Institute of Chicago, gift of Joseph R. Shapiro, 1955.560.

187. *David and Bathsheba*, March 30, 1947. Lithograph on paper; 65.7 x 50 cm (image/sheet). The Art Institute of Chicago, restricted gift of Peter B. Bensinger, 1968.473. Plate 70.

188. *David and Bathsheba*, March 30, 1947. Lithograph on paper; 63.8 x 48.5 cm (image); 65.8 x 50 cm (sheet). The Art Institute of Chicago, Prints and Drawings Purchase Account and Mrs. Albert Roullier and Miss Roullier Fund, 1968.474. Plate 71.

189. *The Faun Musician*, Paris, June 7–11, 1947. Brush and black ink and gouache on paper; 32.7 x 50.2 cm. The Art Institute of Chicago, gift of Dorothy Braude Edinburg to the Harry B. and Bessie K. Braude Memorial Collection, 1998.720. Plate 72.

190. *Faun Musician No. 5*, March 10, 1948. Lithograph on paper; 68 x 51 cm (image); 76.6 x 56.6 cm (sheet). The Art Institute of Chicago, Mr. and Mrs. Paul Gotskind Gift, 1979.137.

191. Plate one from *Poems and Lithographs*, 1949, published December 1954. Lithograph on paper; 64 x 48.1 cm (image); 65.9 x 50.3 cm (sheet). The Art Institute of Chicago, Harold Joachim Purchase Fund, 1969.394.

192. Plates two and three from *Poems and Lithographs*, 1949, published December 1954. Lithograph on paper; 64.9 x 50.2 cm (image); 65.7 x 50.4 cm (sheet). The Art Institute of Chicago, Harold Joachim Purchase Fund, 1969.395.

193. Plate four from *Poems and Lithographs*, 1949, published December 1954. Lithograph on paper; 64.5 x 50 cm (image); 65.7 x 50.3 cm (sheet). The Art Institute of Chicago, Harold Joachim Purchase Fund, 1969.396.

194. Plates five and six from *Poems and Lithographs*, 1949, published December 1954. Lithograph on paper; 64.4 x 49.5 cm (image); 65.7 x 50.2 cm (sheet). The Art Institute of Chicago, Harold Joachim Purchase Fund, 1969.397.

195. Plates seven and eight from *Poems and Lithographs*, 1949, published December 1954. Lithograph on paper; 64.5 x 49.5 cm (image); 66.2 x 50.2 cm (sheet). The Art Institute of Chicago, Harold Joachim Purchase Fund, 1969.398.

196. Plate nine from *Poems and Lithographs*, 1949, published December 1954. Lithograph on paper; 63.3 x 47.9 cm (image); 66 x 50.4 cm (sheet). The Art Institute of Chicago, Harold Joachim Purchase Fund, 1969.399.

197. *The Dove*, January 9, 1949. Lithograph on paper; 54.6 x 69.7 cm (image); 56.4 x 76.2 cm (sheet). The Art Institute of Chicago, Print and Drawing Club Fund, 1950.27.

198. *Modern Style Bust*, March 8, 1949. Lithograph on paper; 64.5 x 49.6 cm (image); 65.6 x 50 cm (sheet). The Art Institute of Chicago, gift from the estate of Curt Valentin, 1955.619.

199. *Venus and Cupid, after Cranach*, May 30, 1949, printed 1975/77, published 1979. Aquatint, with scraping, engraving, and drypoint, on paper; 78.6 x 42.9 cm (image/plate); 100 x 59.7 cm (sheet). The Art Institute of Chicago, Auxiliary Board Restricted Gift, 1979.375.

200. *Large Vase with Dancers*, Vallauris, 1950. Red earthenware clay, ground painted in white engobe; 13/25; 71.2 cm. Collection of Nancy and Steve Crown. Plate 84.

201. *Flowers in a Vase*, Vallauris, 1951 (cast 1953). Bronze, 2/6; 69.9 x 55.9 cm. The Art Institute of Chicago, gift of Mr. and Mrs. Victor K. Zurcher, 1957.70. Plate 79.

202. *Villa in Vallauris*, Vallauris, February 4, 1951. Oil on panel; 88.9 x 116.2 cm. The Art Institute of Chicago, gift of Mary and Leigh Block, 1988.141.21. Plate 80.

203. *Vase with Two High Handles*, Vallauris, 1953. White earthenware clay, engobe decoration, knife engraved under partial brushed glaze, edition 400; 40.6 cm. Private collection.

204. *Portrait of Sylvette David*, Vallauris, 1954. Oil on canvas; 130.7 x 97.2 cm. The Art Institute of Chicago, gift of Mary and Leigh Block, 1955.821. Plate 78.

205. *Variation on the Theme of Las Meninas: Visitors to the Studio*, February 18, 1955. Aquatint and sugar lift etching, with scraping, on paper; 49.5 x 64.7 cm (image/plate); 57 x 76.5 cm (sheet). The Art Institute of Chicago, gift of Mr. Morton O. Neumann, 1956.1066.

206. *Portrait of Jacqueline*, December 4, 1956. Lithograph on paper; 51 x 38 cm (image); 67 x 51.8 cm (sheet). The Art Institute of Chicago, gift of the Print and Drawing Club, 1957.348.

207. *White Owl on Red Ground,* Vallauris, March 25, 1957. Red earthenware clay, decoration in engobes, knife engraved, 66/200; 45.5 cm. Private collection. Plate 83.

208. *Matt Wood-Owl*, Vallauris, 1958. White earthenware clay, decoration in engobes, knife engraved, glazed inside, 42/200; 28 x 21.5 cm. Private collection. Plate 82.

209. *Portrait of a Woman (after Lucas Cranach the Younger)*, Cannes or Vallauris, July 4, 1958. Linocut in colors on paper; 64.5 x 53.5 cm. Private collection. Plate 74.

210. *Jacqueline in Profile to the Right*, December 27, 1958. Lithograph with scraping on paper; 55.7 x 44 cm (image); 66 x 50.5 cm (sheet). The Art Institute of Chicago, restricted gift of Mrs. Leigh B. Block, 1965.33.

211. *Nude under a Pine Tree*, Cannes or Vauvenargues, January 20, 1959. Oil on canvas; 194 x 279.5 cm. The Art Institute of Chicago, bequest of Grant J. Pick, 1965.687. Plate 87.

212. *Jacqueline,* Cannes or Vauvenargues, October 17, 1959. Linocut in colors on paper; 63.8 x 53 cm. Collection of Nancy and Steve Crown. Plate 77.

213. *Combat of Centaurs,* Cannes, December 6, 1959. Black pastel, with stumping and erasing, on paper; 50.7 x 65.8 cm. The Art Institute of Chicago, Dorothy Braude Edinburg Art LLC, 406.2010. Plate 73.

214. *Bathers,* Vauvenargues, June 4, 1961. Graphite on paper; 33 x 50 cm. Ursula and R. Stanley Johnson Family Collection. Plate 85.

215. *Study for "Luncheon on the Grass" after Manet,* Vauvenargues or Cannes, June 6, 1961. Graphite on paper; 33 x 50 cm. Private collection. Plate 86.

216. *Still Life with Lunch I,* 1962. Linocut in dark cream and red on paper; 64.2 x 54 cm (image); 75.3 x 62.3 cm (sheet). The Art Institute of Chicago, Margaret Fisher Endowment Fund; restricted gift of Thomas Baron, 2009.134.

217. *Still Life with Lunch I,* 1962. Linocut in dark cream, pink, and reddish brown on paper; 64 x 53 cm (image); 75.2 x 62.2 cm (sheet). The Art Institute of Chicago, Margaret Fisher Endowment Fund; restricted gift of Thomas Baron, 2009.136.

218. *Still Life with Lunch I,* 1962, printed April 1, 1962. Linocut in reddish brown on paper; 64 x 53 cm (block); 95.5 x 62.3 cm (sheet). The Art Institute of Chicago, Stacia Fischer Bequest Fund, 2004.1118. Plate 97.

219. *Still Life with Lunch I,* 1962, printed April 2, 1962. Linocut in gray-green, reddish brown and cream on paper; 64.2 x 53 cm (block); 69.9 x 62.4 cm (sheet). The Art Institute of Chicago, Stacia Fischer Bequest Fund, 2004.1119.

220. *Still Life with Lunch I,* 1962, printed April 3, 1962. Linocut in dark gray on paper; 64.2 x 52.9 cm block); 75.3 x 62.3 cm (sheet). The Art Institute of Chicago, Stacia Fischer Bequest Fund, 2004.1120.

221. *Still Life with Lunch I,* 1962, printed April 10, 1962. Linocut in reddish brown, gray, and light cream on paper; 64.1 x 53 cm (block); 75.5 x 62.4 cm (sheet). The Art Institute of Chicago, Stacia Fischer Bequest Fund, 2004.1121. Plate 98.

222. *Still Life with Lunch I,* 1962, printed April 10, 1962. Linocut in reddish brown, gray, and black on paper; 64.1 x 53 cm (image/block); 75.5 x 62.4 cm sheet). The Art Institute of Chicago, gift of Frederick Mulder, 2008.553. Plate 100.

223. *Still Life with Lunch II,* 1962, published 1963. Linocut in light cream and black on paper; 64.1 x 53 cm (block); 75.3 x 62.3 cm (sheet). The Art Institute of Chicago, Stacia Fischer Bequest Fund, 2004.1123. Plate 99.

224. *Still Life with Glass under the Lamp,* March 19, 1962, published 1963. Linocut in yellow, red, green and black on paper; 53 x 64 cm (image); 62.3 x 75.3 cm (sheet). The Art Institute of Chicago, the Joseph R. Shapiro Collection, 1965.37.

225. *Bust of a Woman,* Mougins, May 20, 1962. Graphite on paper; 42 x 27 cm. Private collection.

226. *Three Busts of Women,* Mougins, May 21, 1962. Graphite on paper; 42.5 x 26.5 cm. Private collection. Plate 89.

227. *Head of a Woman,* Mougins, May 21, 1962. Graphite on paper; 42.5 x 27 cm. Private collection. Plate 90.

228. *Six Busts of Women,* Mougins, May 21, 1962. Graphite on paper; 41.9 x 27 cm. The Art Institute of Chicago, restricted gift of William E. Hartmann, 1967.539. Plate 88.

229. *Head of a Woman,* Mougins, June 3, 1962. Graphite on paper; 42.5 x 26.5 cm. Ursula and R. Stanley Johnson Family Collection. Plate 91.

230. *Portrait of Jacqueline,* Mougins, December 28, 1962. Graphite with smudging and black ballpoint pen on paper; 34.9 x 25

cm. Richard and Mary L. Gray and the Gray Collection Trust. Plate 76.

231. *Maquette for Richard J. Daley Center Sculpture,* Mougins, 1964. Simulated and oxidized welded steel; 104.8 x 69.6 x 48.3 cm. The Art Institute of Chicago, gift of Pablo Picasso, 1966.379. Plate 93.

232. *Woman's Head with a Crown of Flowers,* Mougins or Vallauris, 1964. Red earthenware clay, printed with engobe pad, black, 75/100; 33 x 25.4 cm. Private collection. Plate 75.

233. *Woman's Head with a Crown of Flowers (Jacqueline),* Mougins or Vallauris, 1964. Red earthenware clay, printed with engobe pad, black, 29/100; 33 x 25.4 cm. Private collection.

234. *Study I for Richard J. Daley Center Sculpture,* Mougins, January 28, 1964. Graphite with yellow, blue, and white crayon and yellow and purple fiber-tipped pen on paper; 27 x 21 cm. The Art Institute of Chicago, gift of Pablo Picasso, 1968.1051.

235. *Study II for Richard J. Daley Center Sculpture,* Mougins, January 28, 1964. Graphite on paper; 27 x 20.9 cm. The Art Institute of Chicago, gift of Pablo Picasso, 1968.1052.

236. *Study III for Richard J. Daley Center Sculpture,* Mougins, January 28, 1964. Graphite on paper; 27 x 20.9 cm. The Art Institute of Chicago, gift of Pablo Picasso, 1968.1053.

237. *Study IV for Richard J. Daley Center Sculpture,* Mougins, January 28, 1964. Graphite on paper; 27 x 20.9 cm. The Art Institute of Chicago, gift of Pablo Picasso, 1968.1054.

238. *Study V for Richard J. Daley Center Sculpture,* Mougins, January 28, 1964. Graphite on paper; 27 x 21 cm. The Art Institute of Chicago, gift of Pablo Picasso, 1968.1055.

239. *Study VI for Richard J. Daley Center Sculpture,* Mougins, January 28, 1964. Graphite with traces of pen and brown ink on paper; 27 x 21 cm. The Art Institute of Chicago, gift of Pablo Picasso, 1968.1056

240. *Study VII for Richard J. Daley Center Sculpture*, Mougins, January 28, 1964. Graphite on paper; 27 x 20.9 cm. The Art Institute of Chicago, gift of Pablo Picasso, 1968.1057R.

241. *Study VIII for Richard J. Daley Center Sculpture*, Mougins, January 28, 1964. Graphite on paper; 27 x 21 cm. The Art Institute of Chicago, gift of Pablo Picasso, 1968.1058V.

242. *Study IX for Richard J. Daley Center Sculpture*, Mougins, January 28, 1964. Graphite on paper; 27 x 21 cm. The Art Institute of Chicago, gift of Pablo Picasso, 1968.1059.

243. *Study X for Richard J. Daley Center Sculpture*, Mougins, January 28, 1964. Graphite on paper; 27 x 21 cm. The Art Institute of Chicago, gift of Pablo Picasso, 1968.1060.

244. *Study XI for Richard J. Daley Center Sculpture*, Mougins, January 28, 1964. Graphite and blue crayon on paper; 27 x 21 cm. The Art Institute of Chicago, gift of Pablo Picasso, 1968.1061.

245. *Richard J. Daley Center Sculpture*, 1967. White chalk on plywood; 100 x 81 cm. The Art Institute of Chicago, gift of Pablo Picasso, 1967.538. Plate 92.

246. *Man Holding a Sheep, Flutist, and Heads*, Mougins, January 11–12, 1967. Colored crayon and colored pencil with smudging on paper; 50 x 65 cm. The Art Institute of Chicago, restricted gift from the estate of Loula D. Lasker, 1968.14R.

247. *Seated Nude II*, July 17, 1967. Watercolor and pen and brown ink on paper; 28.9 x 45.7 cm. Private collection. Plate 94.

248. *Rooster, Woman, and Young Man*, Mougins, September 4, 1967. Colored crayon and gouache on paper; 56.5 x 75 cm. Ursula and R. Stanley Johnson Family Collection. Plate 95.

249. *Laughing-Eyed Face*, Mougins, January 9, 1969. White earthenware clay, decoration in engobes, engraved by knife under partial brushed glaze, 294/350; 32.7 x 24.8 cm. Private collection. Plate 81.

250. *Nude,* August 11, 1969. Graphite and pastel on paper; 50.5 x 65.5 cm. Ursula and R. Stanley Johnson Family Collection.

251. *Reclining Nude (Sleeping Woman)*, September 5, 1969. Graphite on paper; 50.5 x 65 cm. The Art Institute of Chicago, promised gift of Richard and Mary L. Gray and the Gray Collection Trust. Plate 96.

Not in Exhibition

Head (Hanging Guitar with Profile), 1927. Oil on canvas; 27.1 x 34.9 cm. Private Collection. Plate 46.